IMAGES
of America

PARAMUS

IMAGES
of America

PARAMUS

Thalia Goulis and Marc Jablonski

ARCADIA
PUBLISHING

Published by Arcadia Publishing
Charleston, South Carolina

Printed in the United States of America

Library of Congress Control Number: 2014945843

For all general information, please contact Arcadia Publishing:
Telephone 843-853-2070
Fax 843-853-0044
E-mail sales@arcadiapublishing.com
For customer service and orders:
Toll-Free 1-888-313-2665

Visit us on the Internet at www.arcadiapublishing.com

To the people of Paramus, past, present, and future

CONTENTS

Acknowledgments 6

Introduction 7

1. Early Paramus 11

2. Bergen Pines 31

3. Agriculture 45

4. Growth of the Borough 59

5. Commercialization 87

6. Community and Recreation 103

7. Recent History 123

ACKNOWLEDGMENTS

We are so grateful to all the people who helped us on this project with their support, stories, or photographs—we cannot express how lucky we were to be entrusted with these artifacts of our town's history. We would like to extend our gratitude to the following: the Fritz Behnke Historical Museum and its docents; to Fritz Behnke himself, whose dedication and enthusiasm for Paramus's history we were never lucky enough to experience firsthand, though we have felt the effects of his passion, work, and life profoundly; Jim Anzavino and the Tax Assessor's office, whose maps and 1950s photographs were instrumental in our understanding of Paramus's development; David Weinberg, for his kindness and stories; Marianne Duggan at the Paramus Public Library, for her support; Gary and Eileen Kostro, for their enthusiasm, genealogical records, and stories; Fred Cotterell, for his kindness and photographs; Alexandra Castiglia, for her support; Herb Carlough, for his kindness and photographs; the Paramus Historic Preservation Commission, for its dedication, photographs, and contribution to our education of Paramus history; Dorothy Grefrath, Nancy C. Huffman, Anna Lou Kuenzler, Loretta and Ed Lang, Anna Van Baaren, Vilma Babin, Jean Lynch, Dorothy Warburton, Ed Demott, Richard Conroy, Richard Lenk, Carolyn and Frank Straka, Louise Cleenput Suppo, and Cynthia Fordham, who we have mostly never met but whose involvement and firsthand accounts in the 2003 Paramus History Project influenced our project immensely; James V. Van Valen and Frederick W. Bogert, authors of *History of Bergen County, New Jersey*, and *Paramus: A Chronicle of Four Centuries*, respectively, whose books were extensive and enlightening; and our respective families, for their unending support and decision to raise us in Paramus—this book would have been vastly different if they had chosen any other town.

We would like to especially thank Fred Behnke, for his unwavering enthusiasm for this project, and Bill Leaver, who has been an extraordinary help in the process and was the person who initially told us about Paramus's lack of an Images of America book; his encouragement has been constant ever since. Unless otherwise stated, images appear courtesy of the Fritz Behnke Historical Museum.

INTRODUCTION

The story of Paramus does not begin with the birth of the borough in 1922, nor does it begin with the Dutch immigrants in the 17th and 18th centuries. While the cultures and communities have changed over the centuries, the land has not. This earth, which currently supports over 26,000 people, is the same earth that grew celery a century ago. It is also the same earth that the Lenape walked upon centuries earlier. Thus, the story of Paramus is inherently rooted in the land.

About 15,000 years ago, the Wisconsin glaciation retreated in northern New Jersey, leaving several glacial lakes. The Glacial Lake Paramus formed in the area of Paramus, bringing the first humans, along with woolly mammoths, giant sloths, saber-toothed cats, and large prehistoric beavers. After further glacial drift about 10,000 years ago, the Great Red Sandstone Valley was formed in the area, leaving large levels of stratified dirt. The largest of the levels is found in Paramus along the Sprout Brook, which allows swamps and wet meadows to form. These conditions are what contribute to the black dirt, locally called "muck," that is perfect for growing celery but not much else.

The first peoples were archaic hunters, fishers, and gatherers who began to adjust to the changing climate. After thousands of years passed, the humans that inhabited the area became known as the Lenape. They inhabited a large region that today covers New Jersey, eastern Pennsylvania, Delaware, and parts of New York. They are also referred to as the Delaware Indians, named after the Delaware River where some of the tribes resided. This river was named after Thomas West, 3rd Baron De La Warr, the governor of Virginia in the early 17th century. The specific tribes that lived in the area of Paramus were most likely the Tappan and Hackensack Indians who lived in between the Passaic and Hackensack Rivers. They spoke a number of dialects of the Delaware language, a subgroup of the Algonquian language family, throughout the region. They lived in longhouses in areas near streams or lakes, and they relied on agriculture, hunting, and fishing for subsistence. Before Europeans arrived with other material, Lenape Indians made tools out of stone through flintknapping and wood as well as bone and various plants. Their lives, like any culture in any era of history, did not come without hardships and were indeed quite normal, filled with joyous ceremonies and other distinct cultural traditions. In the 17th century, the Hackensack Indians, led by the famous Chief Oratam, were in constant contact with the Europeans. Oratam dealt with many conflicts and treaties between the Lenape and the Europeans regarding the fight over landownership. In the mid-18th century, the Lenape were forced to settle in Oklahoma and Canada.

The first documented contact with Europeans was by the Florentine explorer, Giovanni da Verrazzano, who sailed along the shore of New Jersey around 1524. However, it was not until the voyage of Henry Hudson in 1609 that Europeans began to settle in the area. Because he was working for the Netherlands, he claimed the land for the Dutch and called the area New Netherlands. Around the year 1620, the first settlement in New Jersey was called Bergen, a village a few miles west of New York. The Dutch West India Company officially established the colony of New Netherland in 1624. Not too long after, the Swedish and the Finnish also settled in the

area, setting up trading communities near the Hudson River. In 1664, the Dutch governor Peter Stuyvesant surrendered New Amsterdam, the capital of New Netherland, to the English. Once the English took over control of the area, they divided the region into two parts: New Jersey, named after Sir George Carteret, the governor of the Isle of Jersey; and New York, in honor of the Duke of York. Colonists began to immigrate to New Jersey, embracing the newly established liberal constitution, as well as the fertile land. In 1668, Capt. John Berry received a patent from Governor Carteret for all of the land between the Hackensack and Saddle Rivers. In 1676, after several years of conflict between the Dutch and the English, the province of New Jersey was further divided into East and West Jersey. Several smaller deals were made within the region between the Europeans and the Lenape. In 1662, Albert Zabriskie bought the Paramus Patent, acquiring 11,067 acres. Families such as the Bogerts, Terhunes, Meyers, Bantas, and the Hoppers settled on this particular tract of land. The English divided East Jersey into townships in 1692, officially calling the land between the Hackensack and Passaic Rivers New Barbadoes. It was named after Captain Berry returned from a trip to the island of Barbadoes in a trading vessel. Barbadoes, which was referred to as "Little England" in the Caribbean Sea, was one of the oldest English West India possessions.

In the late 18th century, Bergen County played a vital role in the Revolutionary War, providing land for Gen. George Washington's encampments during the war. Several houses surrounding the Paramus Reformed Church were used as headquarters over the years, serving as military posts that helped cover communication between Morristown and King's Ferry. The Paramus posts also attempted to obtain intelligence of the British plans of action. The British had planned on attacking Paramus after receiving loyalist letters that there were at least 300 continental troops stationed at Paramus, but the patriots in Paramus were prepared for the raid. Although the attack was not extremely successful, the British did manage to take 64 prisoners back with them. By the end of November 1779, Washington moved the army's winter encampment to West Point.

On March 7, 1871, Midland Township became independent from New Barbadoes Township, taking with it the three areas of modern-day Paramus: the Arcola section, the Spring Valley section, and the Paramus section. The Arcola section was located in the southern part of modern-day Paramus near the border of Rochelle Park. Arcola was originally known as Red Mills due to the presence of a sawmill and gristmill on the Saddle River in pre-Revolutionary times. Jacob Zabriskie was the first owner of the mill, and later, Albert A. Westervelt, who converted it into a woolen factory, owned it. After being operated as a woolen mill and a sawmill, the mills soon fell to decay. The Eastons took over the site and removed the mills. They kept the old wheel, but they built a new tower on the property.

The Spring Valley area was originally called Sluckup until 1832. A local legend of the origin of the name tells that a landowner's cow in this region tried to swallow, or "sluck up," his coat that was hanging on a low branch of a tree. Another variation of its origin is that in the Dutch Frisian language, "slukup" is used to describe a boggy hollow—an accurate description of the valleys in the area at the time. The newer name, Spring Valley, refers to the abundance of springs that collected in the many subtle valleys across the region. One of the springs, located in what is now Van Saun Park, is where George Washington and his troops set up camp one night during the Revolutionary War. The first school building in this area was erected before the Revolutionary War and functioned as a school until 1810.

Only 15 miles from New York City, Paramus holds more than 26,000 people, but welcomes many, many more daily at the popular malls. The book will begin with images representing the history of early Paramus from the time of the Revolutionary War until around the 1920s, when Paramus was officially designated as a borough. This section will also include the pioneer European families whose familiar names line street signs and historic homes today. These families include, but are not limited to, the Zabriskie family, the Bogert family, the Cleenput family, and the Behnke family. It is perhaps essential to begin with these families, as they were vital in creating the current municipality. With images of historic homes, we will be able to establish a foundation. We hope to present the reader with an evolution of the area.

The second chapter will discuss one of the first occupations of the 18th and 19th centuries in Paramus: agriculture. The Sprout Brook separates the land into two regions, with the lowlands west of the brook and the uplands to the east. The lowlands were distinct with its muck, or rich black soil, perfect for growing celery. It is said that, at one point, Paramus was the celery capital of the world. Farms located on the uplands were able to grow corn, tomatoes, and cabbage. With the peculiar abundance of the celery crop, the early farmers found it necessary to adapt certain technologies to their advantages. Images in this chapter would include such contraptions and innovations, along with farming as an industry.

The third chapter will focus on the Bergen Pines, a hospital that began as a sanitarium in the early 20th century for those with contagious diseases such as polio and tuberculosis. With different wards for each contagious disease, the hospital grew quite large. Through images of the buildings and patients, it is possible to have an idea of the hardships endured and the medical advances of the time.

The different aspects of the Paramus borough would also be expanded upon. The fourth chapter will focus on the growth of suburbia; the educational evolution from one-room schoolhouses to current schools; the humble start of the police force, which for a while was simply one man; and the monumental role of the firehouses and firemen in both the assistance and involvement in the Paramus community.

The steady commercialization of Paramus is a major influence on how modern Paramus is shaped. Businesses, restaurants, and especially, the three notable malls of the town will all be pictured and discussed in the fifth chapter. Businesses that have closed down but hold a special place in town history and localized nostalgia are noteworthy additions to this chapter, as well as stores and restaurants that are still around and continue to impact local culture. The malls, truly characteristic of this specific area, will be shown from their unassuming origins to their contemporary hustle and bustle.

From this, we move on to the businesses that catered specifically to the recreational enjoyment of the community. This will include the Paramus Skating Rink, the Arcola Amusement Park, and the various bathing beaches available to the public. This chapter will serve to remind the readers of the purely fun aspects of what Paramus used to be like, and how this translates to the town we live in now. Finally, we have a chapter that includes modern-day Paramus attractions and events, aware that history continues to be made.

By no means is this book comprehensive. It is impossible to accurately gather together all of the attractions and stores, experiences, and memories of Paramus. Our resources primarily drove our selection. In other words, we did not leave out images arbitrarily. What we have attempted to do here, however, is to try and represent a touch of Paramus in this book with the hopes of creating conversations throughout the community.

One

EARLY PARAMUS

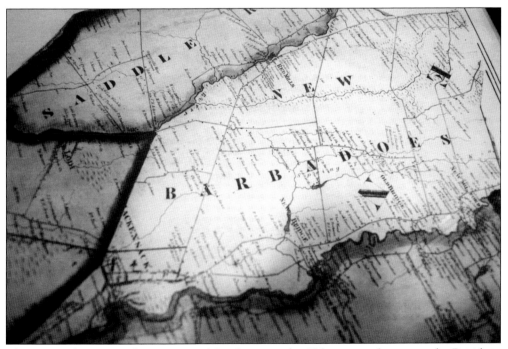

There was a heavy Dutch presence in New Jersey in the 17th century, but it was the British in 1692 that gave this area its name, New Barbadoes, named after the island of Barbados, another British colony. The name was applied to the Paramus area until 1871, when a portion of the land split from New Barbadoes and was renamed Midland Township.

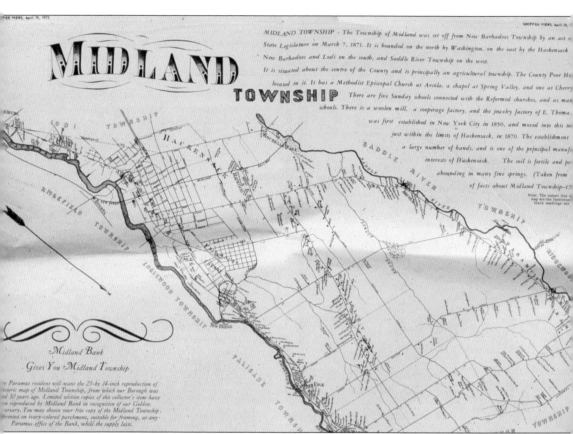

In 1894, New Jersey passed a new borough act that allowed big parcels of land to fracture into smaller boroughs. Maywood, River Edge, and Oradell, local towns surrounding Paramus, became autonomous boroughs through this law. Midland Township was late to the game when, in 1922, differences in opinion on schooling and street lighting constituted a split, breaking Midland Township into the two smaller segments of Rochelle Park and Paramus. (Courtesy of the Tax Assessor's office.)

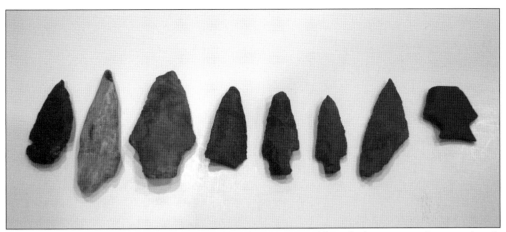

Shown here are arrowheads made and used by the Lenape. Although these particular arrowheads were found on Fritz Behnke's farm, the Lenape settled all over Paramus and Bergen County. It was not uncommon for farmers to come across artifacts such as these as they were planting and harvesting. Another site where arrowheads were commonly found is the land that now houses Victoria Nursery on Paramus Road.

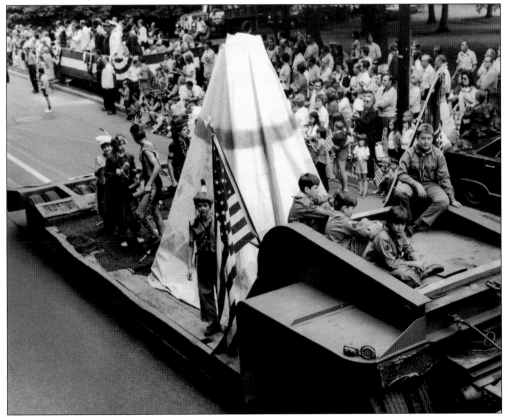

Here, Boy Scouts appear on a float dressed in stereotypical Native American garb during a parade. One can assume they are trying to dress as the Lenape, although this float is an inaccurate representation of the Lenape culture. For example, the Lenape did not live in teepees; rather, they lived in a series of longhouses. (Courtesy of George Egley.)

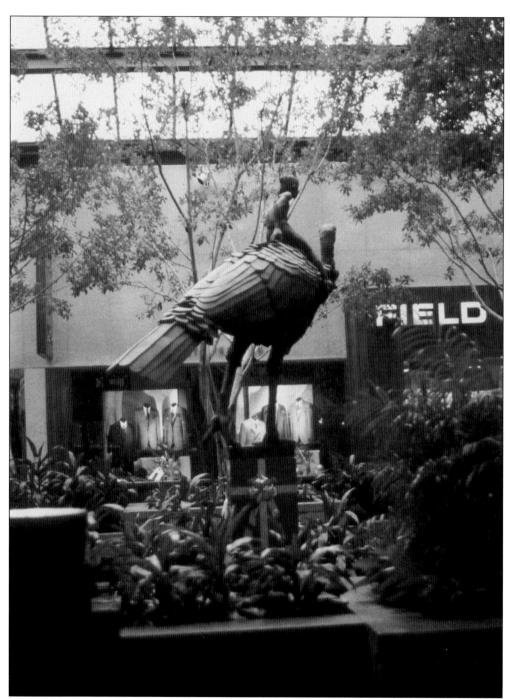

Above is a statue by Christopher Parks located in the Paramus Park Mall that depicts a wild turkey and a Lenape Indian. Although still up for discussion, it is accepted that the name Paramus is a Dutch derivative of a Lenape word or phrase that means, "Where there is worthwhile or fertile land." The name is sometimes interpreted as "land of the wild turkey" due to the abundance of turkey attracted to the crops, mainly corn. Some recorded variations of the name of the town have been "Parames," "Perampsepus," and "Peremessing."

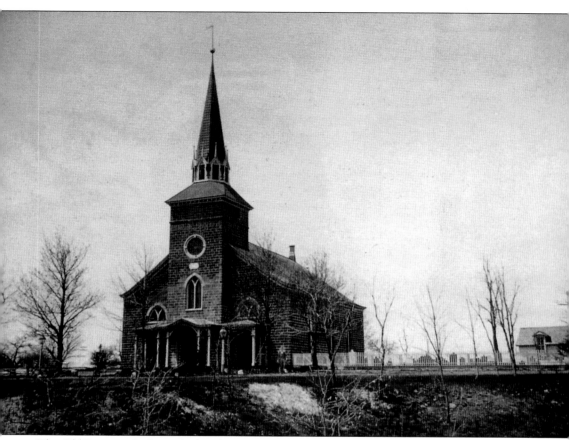

The Old Paramus Reformed Church was established in 1725 and was the center of the Paramus area Revolutionary headquarters; however, there was no one building that was officially designated as such during the war. Thirty letters written by George Washington himself, now located in the Library of Congress, bear the heading "Headquarters–Paramus."

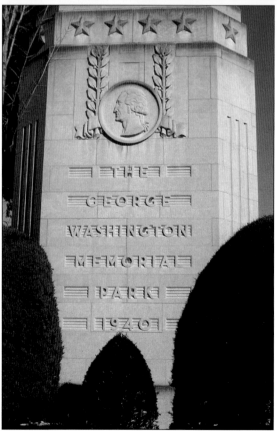

Paramus Road was originally a Lenape trail. During the Revolutionary War, George Washington marched on the road on his way to the Hermitage in nearby Ho-Ho-Kus. Other famous visitors to the Paramus area at the time were Alexander Hamilton, Marquis de Lafayette, Anthony Wayne, Richard Henry Lee, and Aaron Burr.

Pictured here is the entrance to the George Washington Memorial Park, the largest cemetery in Paramus, which was initially built as a whites-only cemetery in 1940. The cemetery is on the corner of Paramus Road and Century Road, and the name was dedicated to the president's involvement in the town during the Revolutionary War.

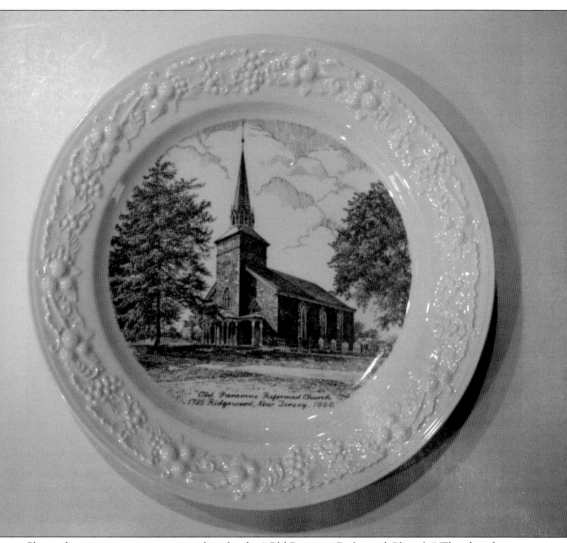

Shown here is a commemorative plate for the "Old Paramus Reformed Church." The church was an important military post because of its proximity to New York City and West Point, which were both headquarters during the war. The British raided it twice in the spring of 1780 with the help of an anonymous local loyalist who informed the British that there were 200 to 250 troops stationed there. Today, that tip is credited to the initials A.Z.

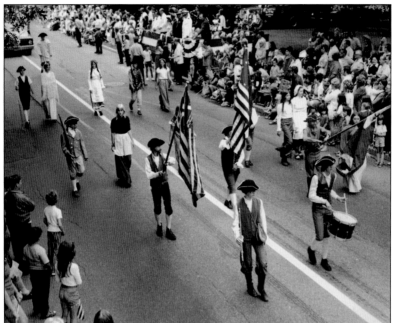

In this 1972 Fourth of July Parade, these men paid tribute to the role Paramus had in the Revolutionary War. In the winter of 1779 and 1780, Paramus had served as a winter encampment for various state regiments and a general headquarters, occasionally visited by George Washington. (Courtesy of George Egley.)

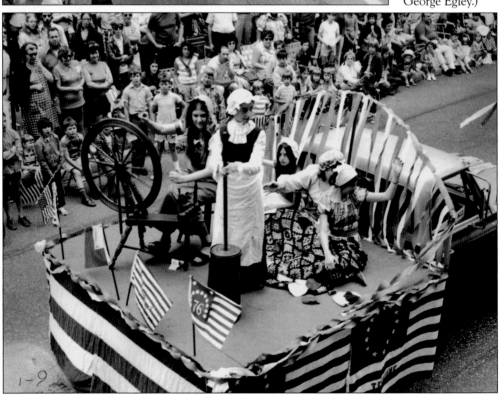

The same parade also honored the women involved in the Revolutionary War effort. The Old Paramus Reformed Church that served as headquarters also functioned as a hospital for wounded or sick soldiers; many local women served as nurses there or hosted soldiers who were quartered in the houses surrounding the church. (Courtesy of George Egley.)

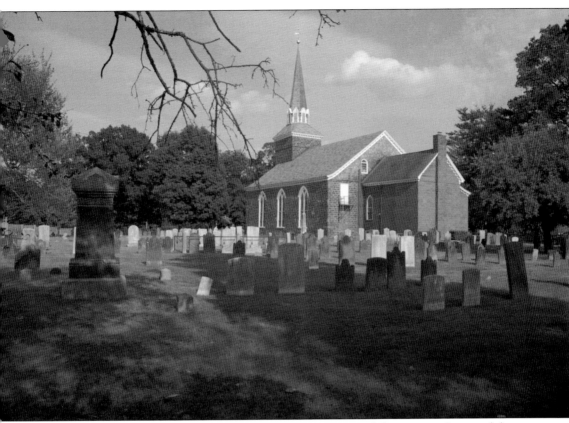

The British attacks on the headquarters were mostly not a tactical decision, as the post did not have many troops or equipment. It primarily seemed to be one small part of a campaign from 1778 to 1780 to terrorize the colonial countryside and psychologically intimidate the troops. The Paramus Reformed Church is still active today, and its cemetery holds several Revolutionary-era gravestones. The church now falls within the Ridgewood town lines.

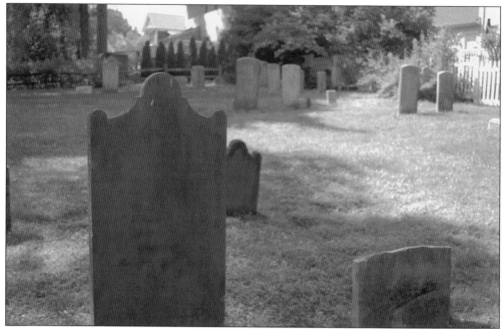

The Old Spring Valley Burial Ground, a historic cemetery directly in the rear of the Behnke farm, contains the graves of the descendants of early settlers in this area, including at least two local farmer militiamen of the American Revolution, Jacobus Brozwer and Henry Banta. Cornelius Demarest, also in the cemetery, served in the 22nd Regiment of the Union Army in the Civil War.

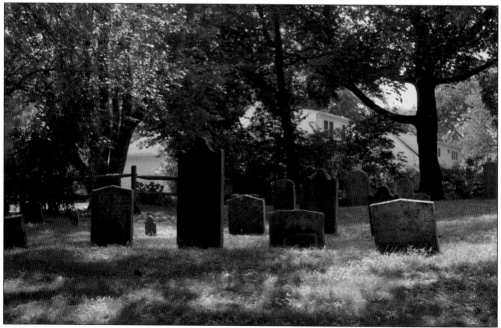

The Old Spring Valley Burial Ground is one of 15 cemeteries in Paramus. There were more, although some, including more Revolutionary cemeteries, were paved over for Paramus's highways. The names on the gravestones are familiar, as many of the people buried came from the pioneer families of the area. Banta, Zabriskie, Demarest, and Howland are all names found on these gravestones.

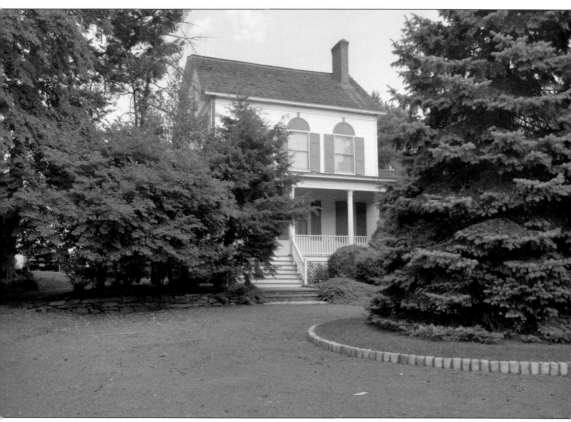

The Terhune-Gardner-Lindenmeyer house was a pre-Revolutionary homestead that belonged to David Terhune, a weaver, patriot official, and freeholder of New Barbadoes from 1779 to 1785. The British raided the farm four times during the Revolutionary War.

This house, owned by Jacob J. Zabriskie, was initially a farmhouse. The architecture is somewhat affected by the Dutch presence in Paramus, as it has elements of the Dutch Colonial style with some influences from the Federal style. It was built in 1826 on the site of an even earlier Zabriskie house and gives some idea of the longevity of the Zabriskie legacy in Paramus and surrounding areas. This house stayed in the Zabriskie family for 132 years.

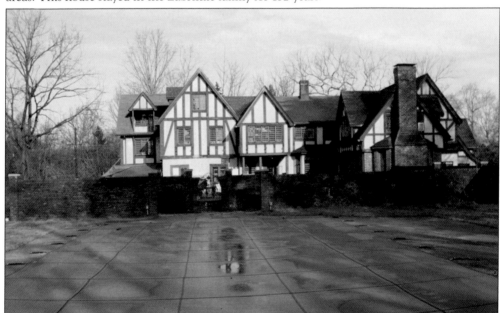

The Stockton House, built in the early 1900s (most likely 1908), belonged to Kenneth E. Stockton, who was president of the American Cable and Radio Corporation from 1948 to the time of his death. It was a shining example of the Tudor Revival architecture style, designed by the local famed architect Carl Kemm Loven. The house was demolished in the spring of 2014. (Courtesy of the Paramus Historic Preservation Commission.)

Constructed in 1899, the Easton Tower is a three-story tower made of sandstone and concrete, located on the Arcola grounds. The tower, designed by architect Henry S. Ihnen, was commissioned by Edward Denison Easton to be built on the intersection of Red Mill Road, off Saddle River Road. The purpose of the tower was to pump water to irrigate his estate, but Easton was also very concerned with the aesthetic contribution the tower would have to the 47-acre property. This picture, taken in 1920, shows how successfully the tower contributes to the scenic beauty of the estate.

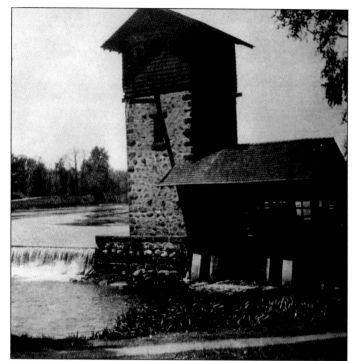

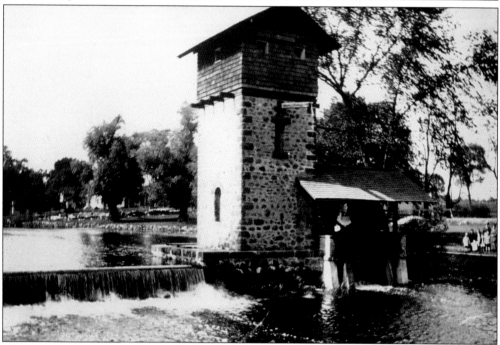

The Easton Tower is sometimes mistakenly referred to as the Red Mill because it is located at the site of the previous Zabriskie Mill, which was in operation before 1745 as a gristmill. The mill, a bright-red color, gave the area the name "Red Mill," and the Easton Tower was built on the site after the original mill was demolished in 1894. The tower's wheel provided water for the fountains and pond on the estate of Edward D. Easton, the founder of the Columbia Gramophone Company.

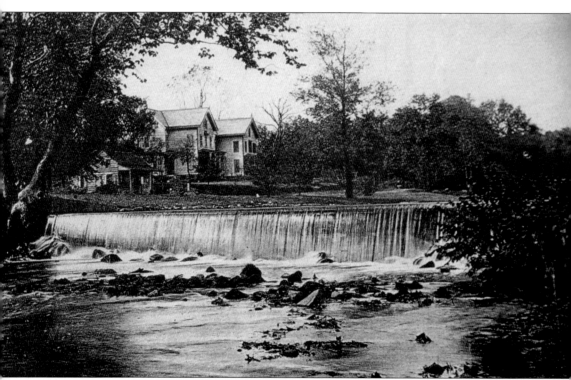

Director D.W. Griffith, one of the most influential early cinematographers, utilized the Arcola grounds. He is perhaps most famous for movies like *Birth of a Nation* and *Broken Blossoms*. Several of his films featured the Easton Tower, waterfalls (pictured above), and park grounds. Other directors that used the grounds were Louis J. Gasnier, who filmed *Perils of Pauline* there in 1914, and Joseph Smiley, who filmed the short *Over the Hills* (1911).

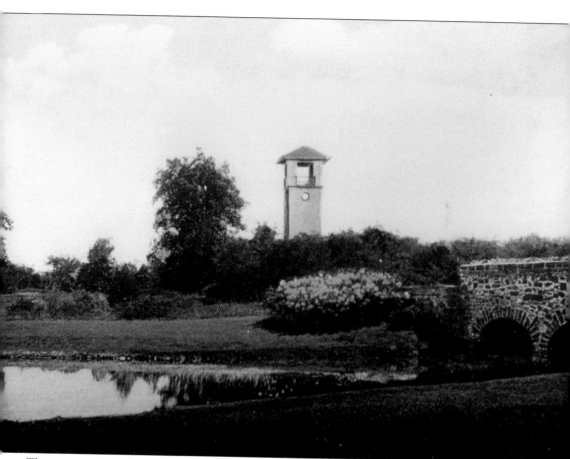

The property, including its gardens, is known for its scenic beauty and is one of Bergen County's most photographed spots. The site was sold to Bergen County in 1956, and the county's park commission restored the tower in 1967. It is still intact today, but the water mill is no longer running, and roads and highways have divided up the 47-acre estate

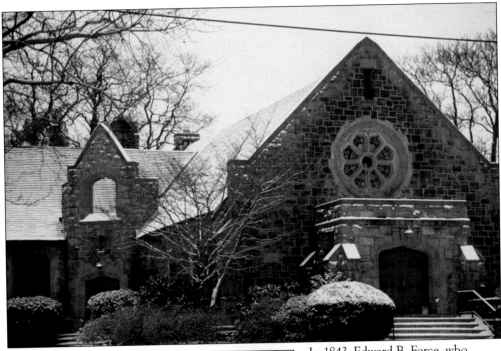

In 1843, Edward B. Force, who had inherited a mill and farm at Red Mills, was instrumental in the construction of the Methodist Episcopal Church of Paramus at Red Mill. The church was constructed mostly from logs cut in his mill. After several remodels, moves, renames, and one fire on Valentine's Day 1911, the new Tudor-style church with its iconic red doors was built and is now known as the Arcola United Methodist Church.

This structure on the Easton estate is referenced to as the "Old Furnace," although its true function remains somewhat a mystery. Some guesses are that the furnace was used to melt ice or heat water in the winter, or that the water powered the furnace.

Built around 1915, the same year construction started at Bergen Pines Hospital, the House of Divine Providence for Incurables was built alongside and across the street from Mount St. Andrew's. It was a retreat for nuns, as well as an 80-bed hospital and church. It burned down in 1929 and was rebuilt as Annunciation Church. It remains an active Roman Catholic parish today.

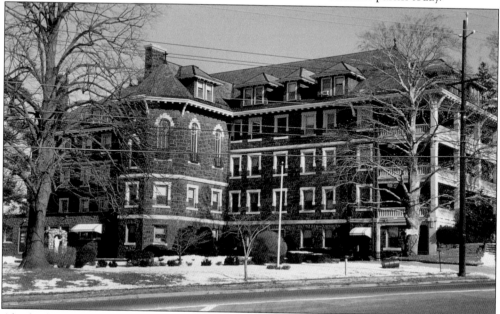

Also built in 1915 by the Catholic Diocese of Newark, the Mount St. Andrew's Sanitarium was a home for aged men and doubled as a retreat for priests. The building still exists today, although it is undergoing major construction.

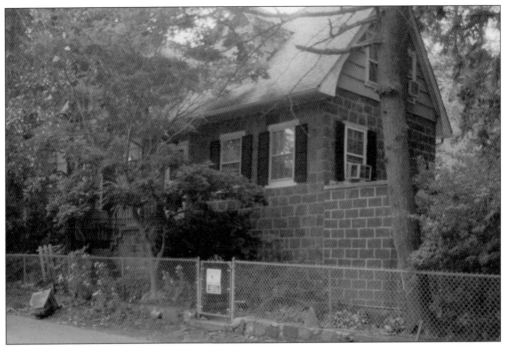

Bergen County was the largest slave-owning county in New Jersey in the 18th century; slavery was common in the state as early as in the late 17th century. This building and others like it were homes to a handful of free black families in the early 19th century, like the Stuart family. The members of the small community within Paramus were mostly farmers. The majority of the residents were slaves previously owned by the Zabriskie family and freed.

Shown is the back of the historic house pictured at top. At one point, a church stood next to the house, though it burned down in the 1930s. The house remained in its original condition in the Dunkerhook neighborhood until 2011. There was a campaign to save the building by moving the structure to the grounds of the local community college to preserve this one piece of black history left in Paramus. However, the building was unexpectedly demolished before the campaign was completed.

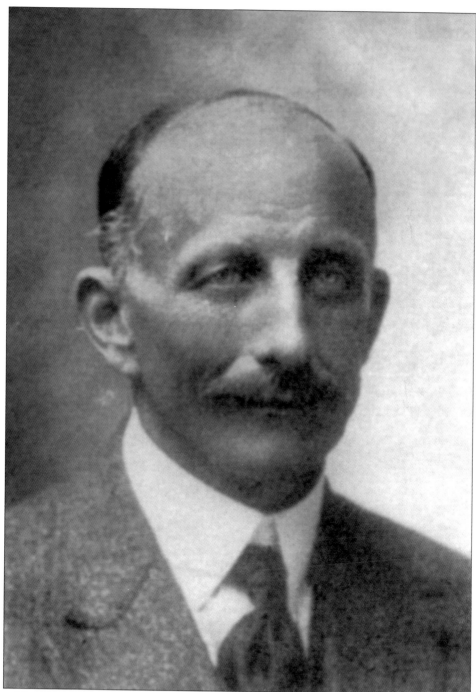

Republican Otto Weisgerber is pictured; he was elected as the first mayor of Paramus in 1922 and served until 1928. He has been succeeded by Robert D. Coombs (1929–1930 and 1933–1934), Albert Van Saun (1931–1932 and 1935–1936), Benjamin Manning (1937–1940), Adolph A. Haase (1941–1948), Emil J. Geering (1949–1952), Fred C. Galda (1953–1964), Robert Inglima (1965–1966), Charles E. Reid (1966–1974), Joseph Cipolla (1975–1990), Clifford Gennarelli (1991–2002), James J. Tedesco (2003–2010), and the current mayor, Richard LaBarbiera.

Bergen County was first named and recognized in the last half of the 17th century. Initially, the Paramus area was just outside of the Bergen County lines, as it only included the area between the Hudson and Hackensack Rivers. However, later lines included the town, albeit under the different names of New Barbadoes and Midland Township. Paramus, as that name, officially became an active part of Bergen County in 1922 when it became its own town. Part of the town's activity was, of course, to adopt the Bergen County song when it was created seven years later.

The Paramus seal includes three historical aspects of the town's various roles. The wild turkey, millwheel, and plow symbolize the most common interpretation of the Lenape name ("Peremes," meaning "land where the wild turkey abounds"), the town's milling community, and the farming significance of the town, respectively. The outer design signifies the town's government representatives—one star each for the mayor and six council members. The seal is usually seen in the town's colors, blue and white.

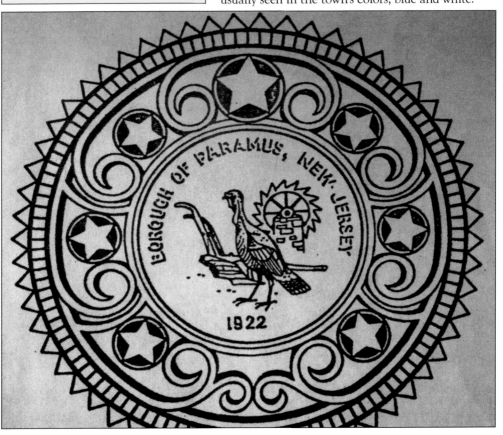

Two

BERGEN PINES

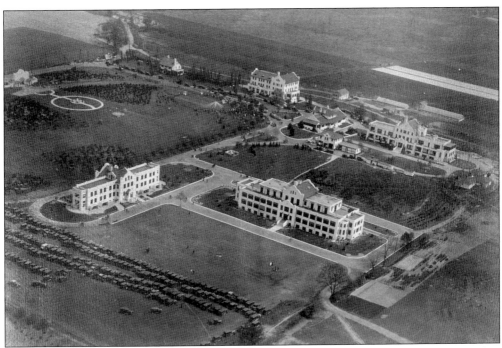

Within 10 years, the Bergen County Isolation Hospital transitioned from construction of its first building to at least one structure per contagious disease, dormitory buildings for the doctors and nurses, and office buildings. Most isolation hospitals at that time were extremely simple, and Bergen County wanted a more modern facility, so several buildings—or pavilions, as they were called—were constructed in the Spanish Mission style.

Construction for the Bergen County Isolation Hospital started in 1915. All paving and building was done by hand. Originally, only one building was constructed, and patients were first admitted on August 16, 1916. The patients were mostly admitted for infantile paralysis, more commonly called polio, and three days later, the hospital had its first fatality, a year-old boy named Thomas Callahan.

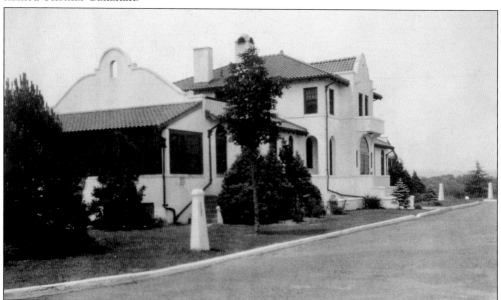

The hospital's nurses were a vital component to the Bergen County Isolation Hospital operation, so much so that in 1924, a separate dormitory was built to house 50 nurses. Public transportation at the time was insufficient for nurses to travel to the hospital daily, so nurses were required to live on the hospital grounds at the time. The hospital also constructed a house for the resident doctor, Dr. Morrow.

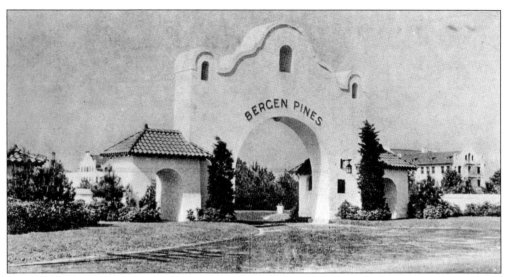

In 1922, Dr. Morrow suggested that pine trees should be planted on the hospital grounds to add to the healing process of the patients, and reportedly, 1,000 trees were planted. In 1924, the name of the hospital changed from the Bergen County Isolation Hospital to Bergen Pines. The iconic front entrance gate to the hospital, also built in a Spanish style, was constructed in 1925 and reflected the name change.

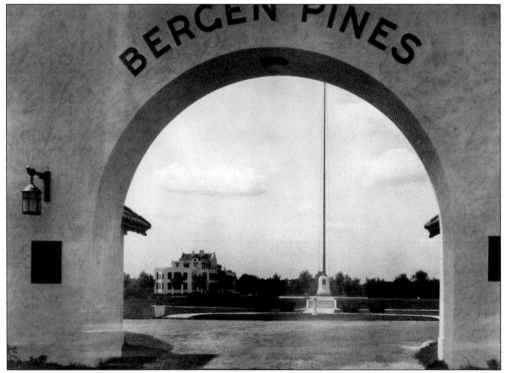

This closer look at the grounds through the gate allows for the perspective of the patient upon entering. The Bergen Pines front entrance gate was iconic as it was foreboding. Because of the severity of the illnesses at the hospital, many patients believed that to go through the front gate as a patient meant that it was unlikely they would ever exit the gate.

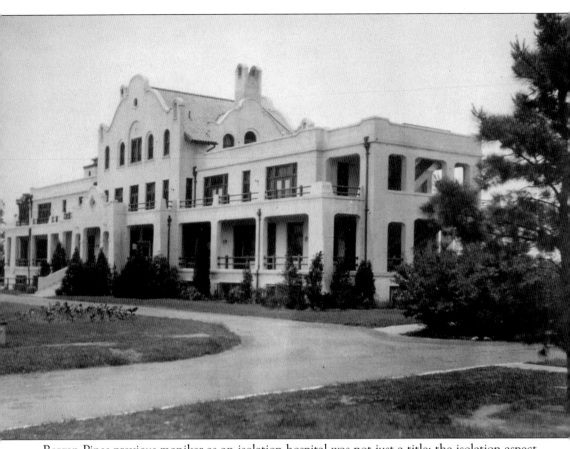

Bergen Pines previous moniker as an isolation hospital was not just a title; the isolation aspect was taken very serious. The hospital discouraged patients' family and friends from visiting but many did anyway. This building, functioning as a quarantine area for the sick, was designed with ledges, as the only way visitors could see or talk to their loved ones was on these ledges and through the glass. Communication was either in the form of screaming through the windowpanes or holding up written signs.

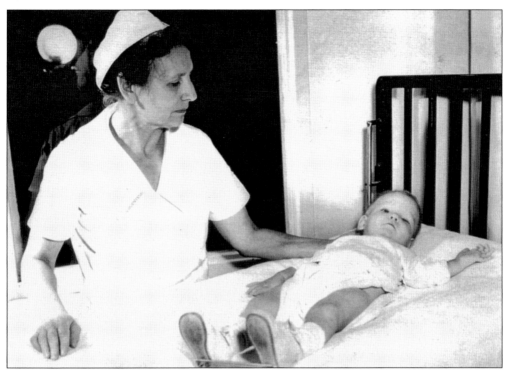

The main diseases treated by the hospital were polio, tuberculosis, scarlet fever, diphtheria, and small pox. Pictured above, a nurse tends to a young polio patient.

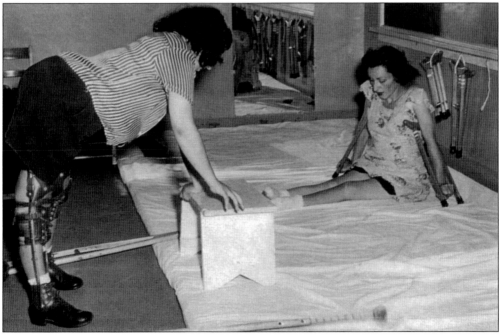

Polio did not only affect children and infants, however, and many older patients who had contracted polio suffered from muscle weakness or paralysis. The hospital conducted physical therapy amongst patients who were dependent on crutches or splints.

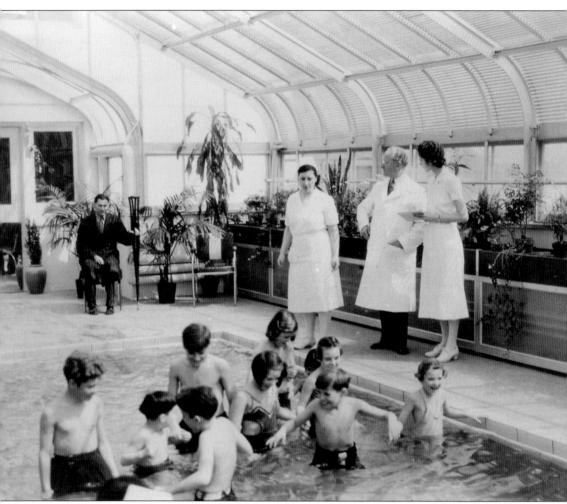

Aquatic therapy was also used at Bergen Pines hospital for polio patients. This form of rehabilitation is still practiced today. The use of aquatic therapy was somewhat ironic considering polio was thought to travel and spread through water, causing a panic in the first half of the 20th century and scaring many people from swimming in pools and oceans.

The iron lung, also known as a negative pressure ventilator, was mostly used at Bergen Pines for polio patients. If the poliovirus affected a patient's central nervous system, muscle weakness or paralysis was common. Chest paralysis or weakness led to difficulty breathing, and the iron lung did the breathing for the patients.

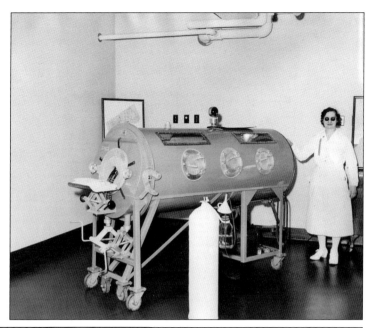

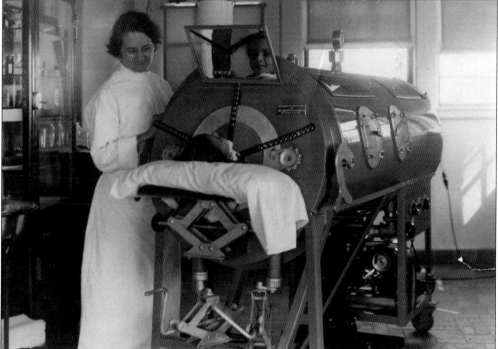

The iron lung had some features that were useful to the patient, depending on the model or type. Some, like this one, had a mirror so the patient could see what was going on behind them; some had a clip so the patient could read a book or a magazine, but a nurse had to turn the pages. If they were careful, the patients could eat while in the machine, but only if their chews and swallows were in sync with their inhales and exhales. Mostly, patients slept while in the machine, as the physical exertion of breathing usually required made them quite tired, but in the iron lung, the machine did most of the hard work.

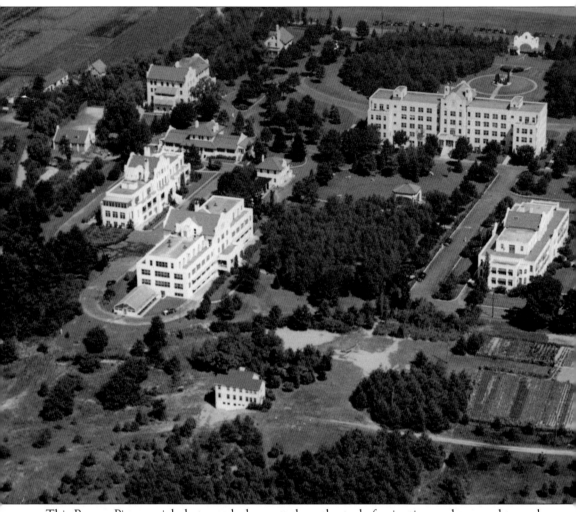

This Bergen Pines aerial photograph does not show the truly fascinating underground tunnel system constructed by the hospital. In order to move supplies discreetly through the grounds, or to avoid the bitter cold in the winter, the staff navigated underground tunnels that ran between each building.

Although the hospital had numerous laboratories, there was not much equipment or expertise to conduct valid medical research. Some treatments were decidedly questionable, especially the treatment for tuberculosis, which was by far the most common disease among the patients admitted. For example, tuberculosis treatment included sun therapy, rest, and a good diet but also included frugality, neatness, and maintaining a pleasant disposition.

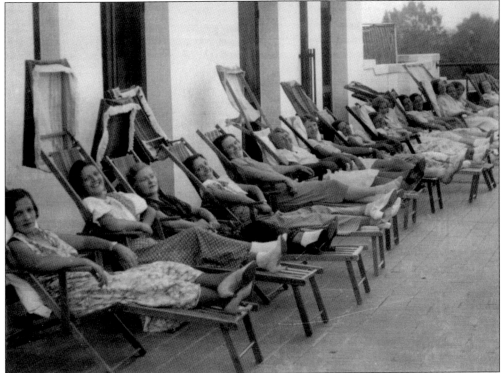

Medical research at the time indicates that hospitals were very aware of the existence of the bacterium that actually causes tuberculosis, but heliotherapy, or sunbathing treatment, was thought to kill that bacteria. As seen above, patients did not mind the long hours of sunbathing prescribed to them, but other details of patients' lives were strictly and obsessively regulated, and patients were told their previous or current behavior was most likely to blame in their contraction of the disease.

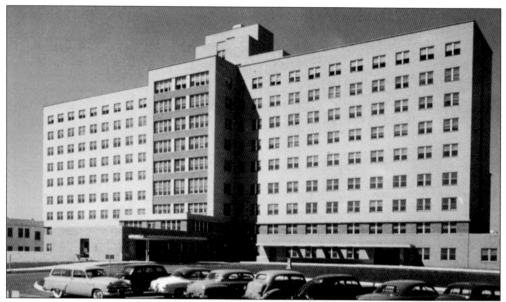

Patients were told treatment would not help if it lasted less than three months, but it would probably not improve much if continued after three or four years. The average stay of a tuberculosis patient was a little over a year. In that time, patients were restricted to their quarantined building, and their loved ones were discouraged from visiting because of the contagious nature of the disease. The nine-story building pictured above was added to the hospital campus later on, after the hospital relaxed its policies on quarantine.

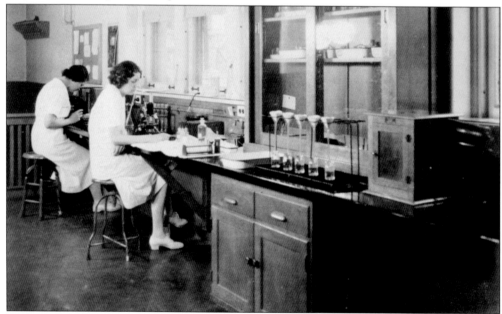

Many patients ended up rebelling because of the scrutiny and isolation. Patients would refuse to sign permission forms, joined in on a general subculture of defiance against nurses and doctors, and conducted relationships with other patients, which was also highly discouraged by doctors and nurses. Rebellious behavior was frequent, if only to resist the monotony and frankly discouraging treatment they were receiving.

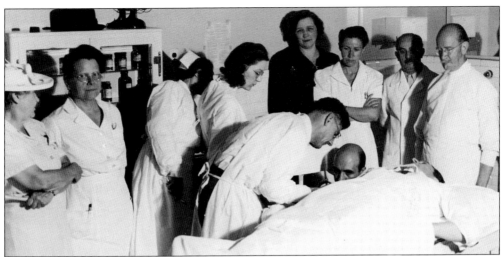

Ten members of the Bergen Pines hospital staff are seen here observing the extraction of blood plasma from a donor in 1942. Blood plasma donor clinics were very popular in the early 1940s; before its direct involvement in World War II, the United States played a major role in the "Blood for Britain" project, which provided blood, and especially plasma, donations to injured British soldiers. In 1941, the Red Cross provided blood for American soldiers through its National Blood Donor Service, which ran until 1945.

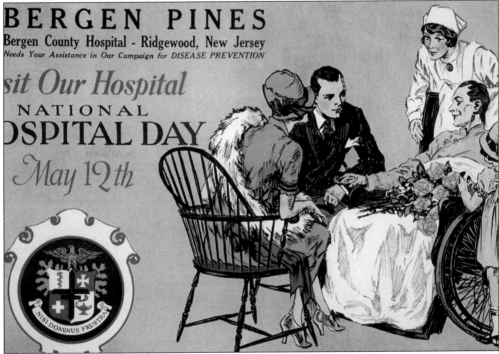

Bergen Pines' Hospital Day was a local holiday dedicated to celebrating excellence hospital administration and practices and was always held on or around May 15, Florence Nightingale's birthday. The National Hospital Day Award of Merit was awarded to the hospital most committed to exemplary community practices, and in 1929, Dr. Morrow, the resident doctor and superintendent of the hospital, heavily and successfully campaigned to win the award.

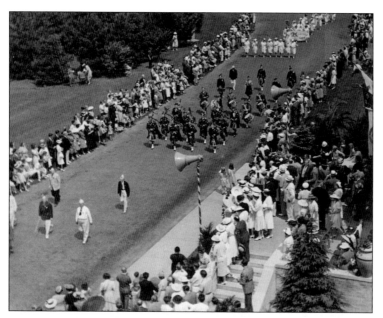

Part of that campaign was the celebration on May 12, 1929. Marching bands, a parade, flight displays of the airplane ambulances, a minstrel show, and a famous guest speaker attracted 5,000–15,000 visitors. Bergen Pines was the only New Jersey submission for the Merit Award, and the number of visitors to the event far surpassed the national second-place winner for the 1929 award.

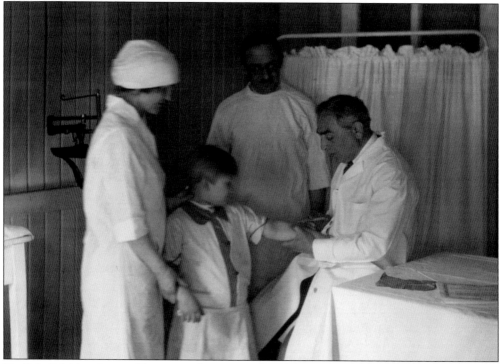

Dr. Bela Schick, a famous Hungarian doctor, was the guest speaker at the National Hospital Day event. Dr. Schick developed the Schick Test in 1913, also known as the "Schick-Toxin-Anti-Toxin Method," which was designed to detect a positive or negative presence of diphtheria in a patient. Schick, in 1929, had recently moved to New York City and was conducting a five-year campaign to eradicate diphtheria, which was generally successful. After delivering his speech, he conducted a special clinic and delivered the test to Bergen County children, seen above.

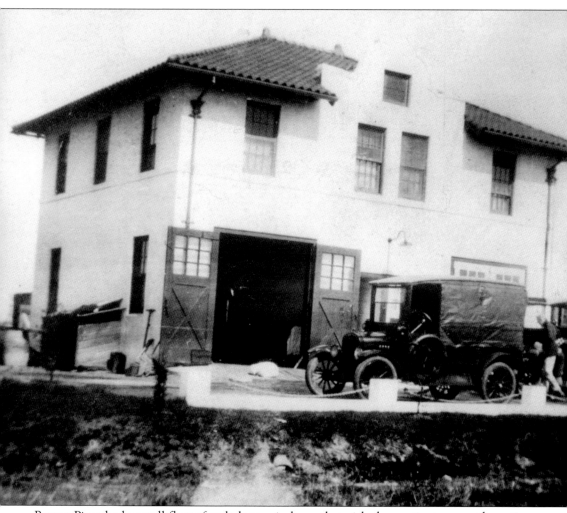

Bergen Pines had a small fleet of ambulance airplanes that picked up patients across the entire county. There were also actual automobile ambulances, as well as a bus that ran from Hackensack to Westwood and through Bergen Pines, though that was mostly for visitors, employees, and mildly sick patients to-be. All these vehicles were stored in the hospital garage.

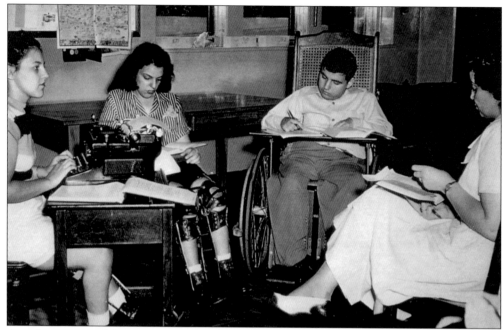

As polio was one of the most common infectious diseases in Bergen Pines, and as polio primarily affected children, Bergen Pines had a makeshift school system. The three patients/students on the left attend their class in their braces and wheelchairs and take notes—note the typewriter—while the teacher (right) reads to them.

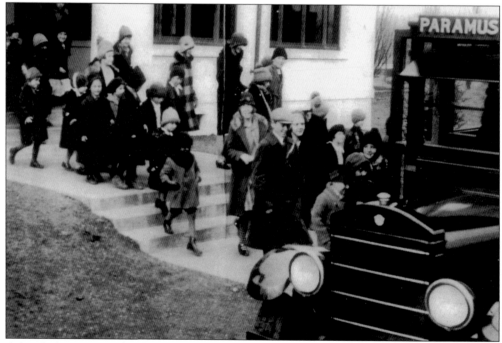

A local elementary school takes a field trip to the new and exciting Bergen Pines Hospital; however, the teachers did not mention beforehand that the ultimate purpose of the field trip was to get the students inoculated.

Three

AGRICULTURE

Besides just splitting Paramus into two distinct farming regions, the Sprout Brook was used as a minor trading route before any major roads heading to New York were established in Paramus. Prior to the 17th century, the brook was known to the Lenape as the Wynochsock Brook but was renamed by European settlers.

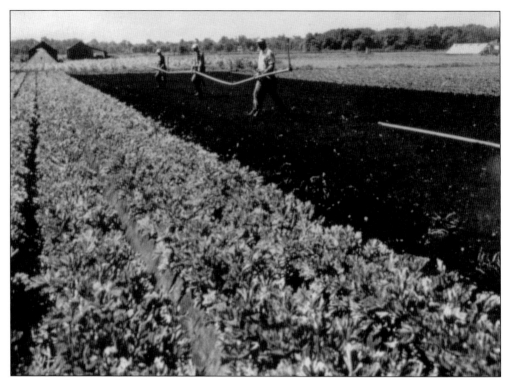

After the American Revolutionary War, Paramus emerged as a farming community. The Sprout Brook divided the land. Barely visible today, the brook runs into the Saddle River almost parallel to what is now Route 17. West of the brook was known as the lowlands, distinct with its muck, or rich black soil, which was perfect for growing celery. It was said that Paramus was the celery capital of the world at one point.

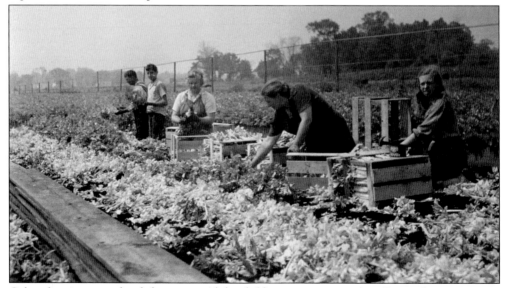

Celery farming was a family business, and the children were no exception. During harvest season, all members of a family got up together at 6:00 a.m. to start the day's work and finished around dinnertime. The only days children did not work were school days.

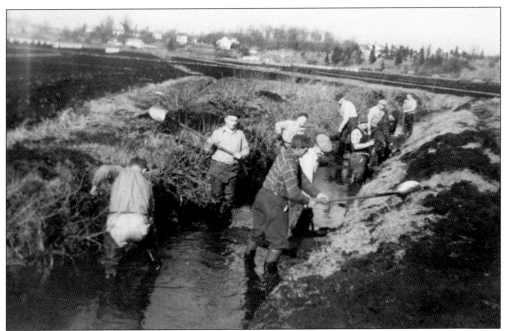

This picture was taken in the late 1930s at the site of what is now Paramus Park Mall, with Winters Avenue on the left and East Ridgewood Avenue straight ahead. The celery farm workers are digging out ditches to let water come through from the Sprout Brook, Paramus's main source of farming irrigation.

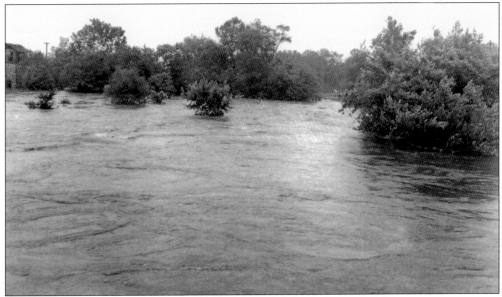

Although water was necessary for celery farming, too much was destructive. Flooding was very common, and if the water in the celery fields was not drained in 24 hours, then the entirety of the celery crop was destroyed. Because it was at least a yearly occurrence, celery farmers complained to borough officials, and the Sprout Brook was cleaned and widened to allow for easier irrigation drainage. There were also individual irrigation systems on each celery farm property, which had to be maintained regularly.

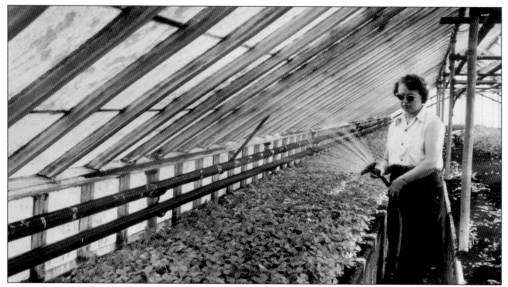

Only one or two celery farms were able to install greenhouses on their farmland. Celery is usually planted in the spring and harvested in the fall, but the greenhouses allowed farmers to plant and harvest celery during the winter, when they usually would have had months of no work and no income. The greenhouses allowed these celery farmers to double their farming seasons during each year as well as double the crops they produced. However, greenhouses were easily damageable by snow, wind, or storms. Pictured above, Charlotte Krause Drenth waters the indoor celery crop on Drenth Farms.

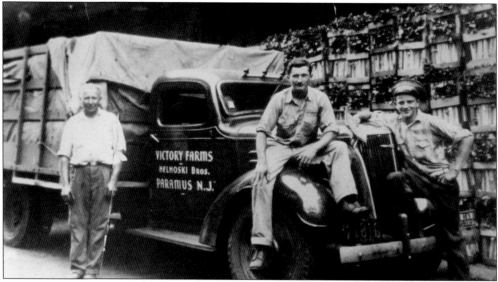

During Prohibition, illegally manufacturing alcohol, or moonshining, was very much active in Paramus. The manufacturers, because there were several, had to be extremely careful, especially during the period between 1929 and 1932, when jail time and fines for alcohol possession, production, or sale were most severely enforced. The moonshiners would rent barn space from farmers, and their stills would move from one barn to the next to avoid suspicion. Some farmers/moonshiners would deliver alcohol to New York City hidden in their celery, as seen in the background of this picture; celery crates were abundant and great hiding spots.

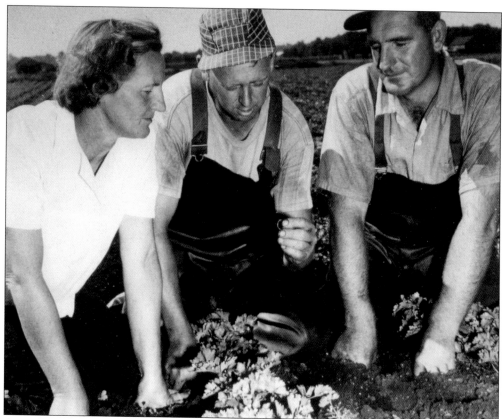

Anna Drenth Kiel (left) lost her graduation ring from Ridgewood High School in her family's celery fields soon after she graduated. After marrying and moving off the Drenth farms, her cousin Albert Drenth (center) found the ring almost 20 years later while working part time for Anna's brothers John (not pictured) and Tunis Drenth (at right). The ring was lost in the 1930s and recovered in the 1950s.

Pictured at right are Elmer Drenth (left) and George R. Drenth (right) on their tractors, carrying celery. The Drenths were a prominent celery-farming family and were one of the last ones to keep their celery farm running. Today, there are no celery farms left in the town.

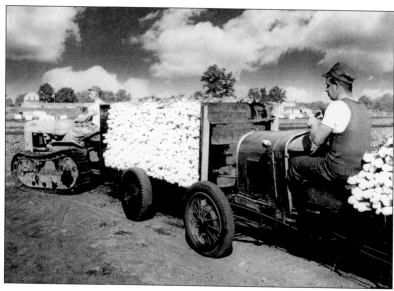

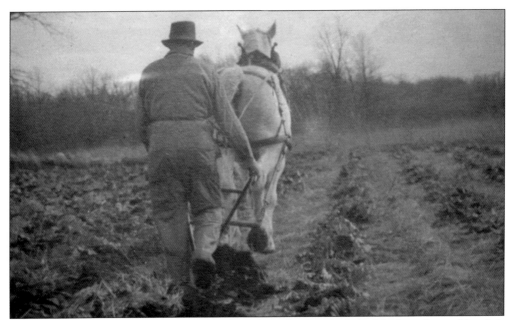

The land east of the Sprout Brook was called the uplands, which had higher elevated land. It was able to grow crops such as tomatoes, cabbage, corn, and rhubarb. Other crops grown in the uplands included strawberries, cherries, apples, peaches, lettuce, and cantaloupe. Much of the produce was transported and sold to markets in Paterson and New York City while other farmers sold locally with roadside stands.

In early Paramus history, restaurants were a scarcity, the complete opposite condition of the abundance of restaurants the town has today. Roadside stands were much more common. As Paramus was a farming community, many farms would build and maintain these stands facing whatever the most popular road outlining their properties was. Visitors passing through on their way to New York City and other areas would stop by for fresh fruit and produce. The roadside stand culture remained until well into the 1960s.

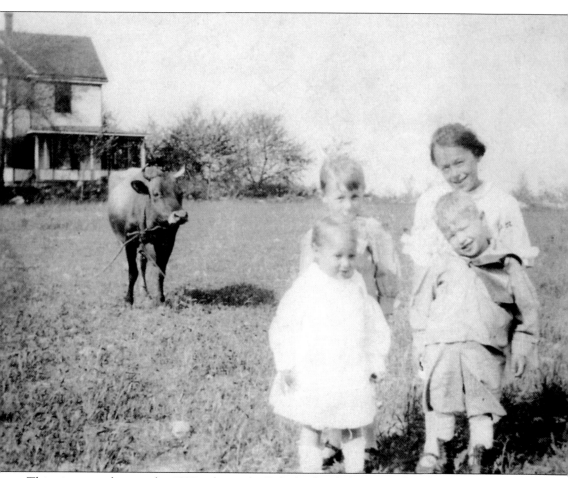

This picture, taken in the 1920s, shows the Behnke family homestead and farmland, which was located on upland farming territory. Those included in the photograph are, from left to right, (first row) Evelyn and Fritz Behnke; (second row) Walter and Helen Behnke and, in the background, Daisy the cow. Livestock, especially horses, were also very common and useful on upland farms.

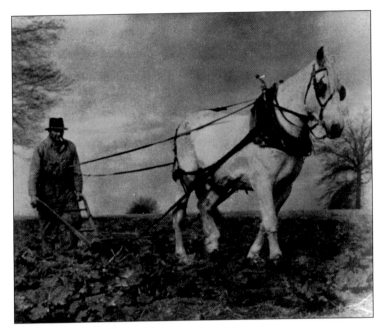

Horses were useful in several ways. For upland farming, they were crucial in drawing plows and other tools. Horses were also used in lowland celery farms, although they needed special horseshoes in order to not sink down in the muddy muck soil. Horse-drawn carriages or wagons were also popular modes of transportation among farmers to get to New York City or other marketplaces in order to sell their crops.

A farmer's typical day was to get up at 6:00 a.m., work in the fields until 6:00 p.m., drive their horse-drawn wagon to a New York City produce marketplace, and return around midnight. That schedule was extremely tiring during the farming months, so farmers typically fell asleep on the drive home, which was fine, as the upside to having a horse-driven wagon is that the horses were intelligent enough to learn the way home themselves and return the farmers safely around midnight.

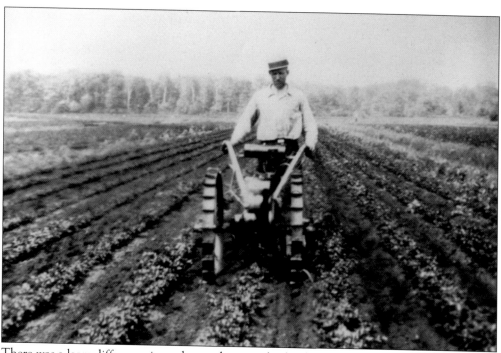

There was a large difference in tool usage between lowland (celery) farming and upland (largely tomato) farming. Celery farmers typically used lighter hand tools, while upland farmers used horse-drawn tools and, later, tractors and mechanized tools, pictured here.

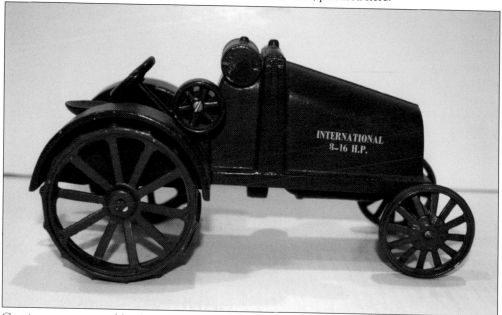

Cast iron tractor toys, like this one, were popular in the late 1930s. The toys were made to look like actual tractor models, in this case like the International Harvester 8-16. In a farming community like Paramus, giving toys like this to children perpetuated the farming family traditions because the tractor models farmers played with as children were likely to be the same or similar to the tractors they used as adults.

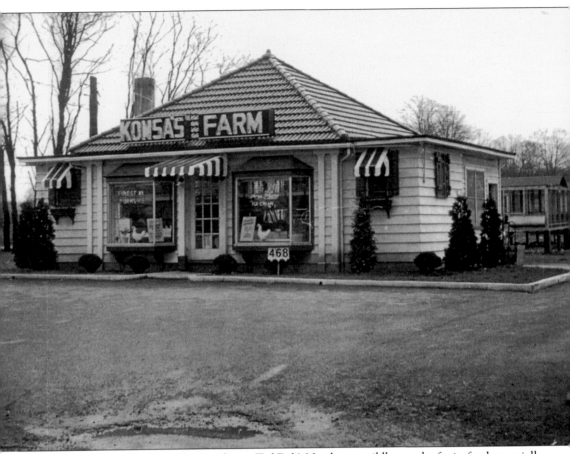

Komsa Farms on Spring Valley Road, now Ted Deli's North, was wildly popular for its food, especially its barbecue chicken. Unfortunately, as Paramus transitioned into a nonfarming community, the farmland, livestock, and chickens were all sold off and Komsa Farms itself disappeared. The farm was fondly remembered for its Christmas decorations of life-sized wooden statues of comic book characters and farm animals that lit up at night. (Courtesy of the Tax Assessor's Office.)

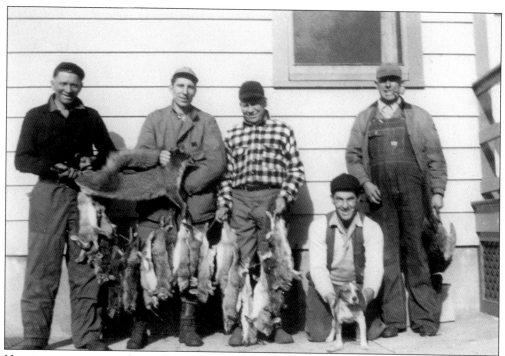

Hunting was very popular in Paramus. Rabbits, pheasants, and quails were plentiful; the area where Paramus Park Mall is now was a well-known hunting spot for quail especially. Sometimes, as pictured, dogs were used for tracking but not always. It was not merely for sport, however, as every animal pictured above, with the exception of the fox, was eaten.

Smaller animals like squirrels, skunks, and chipmunks were usually tracked with dogs, and the hunters could profit off the pelts of the animals. Hunters could get around 25¢ to 50¢ for each animal pelt.

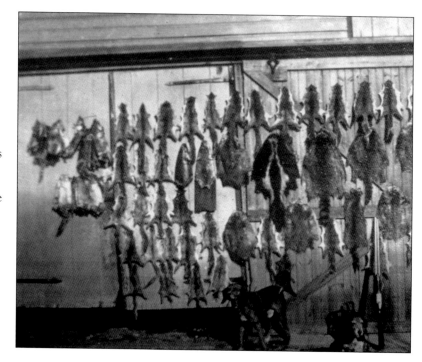

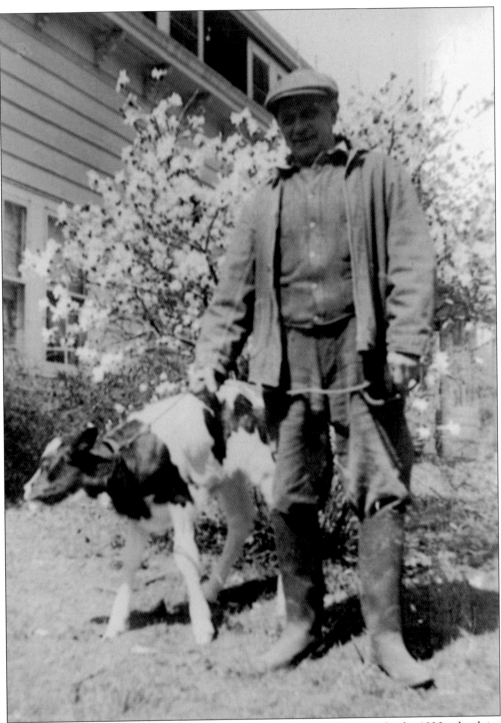

The Cleenput Dairy was perhaps the largest dairy distributor in Paramus. In the 1930s, the dairy was located on Paramus Road on what is now Orchard Hills Golf Course, although it moved shortly after. Owner Peter Cleenput is seen attending to a calf on the dairy property in the spring of 1936.

The livestock in Paramus mostly consisted of cows, chickens, sheep, horses, and pigs. Funnily enough, when the Bergen County Zoo opened in 1960 at Van Saun Park in Paramus, at a time when farming was in somewhat of a decline, the animals that were exhibited were also cows, chickens, sheep, horses, and pigs. These specific pigs belonged to the Drenth family and were housed on East Ridgewood Avenue.

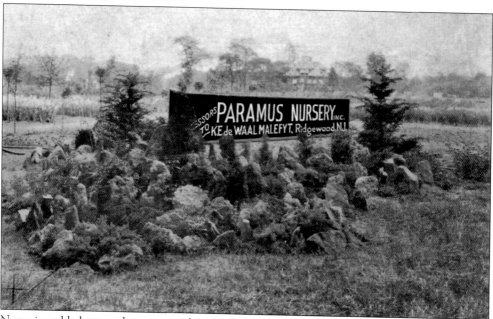

Nurseries sold plants and trees to residents and farmers alike. Karel and Jemima De Waal Malefyt, who moved their entire family of seven boys and six girls to Midland Township, founded the Paramus Nursery in 1904. The nursery was located at 582 Paramus Road. In the background of the picture, one can make out the barn, shed, and greenhouses also on the property. The land is now Victoria's Nursery.

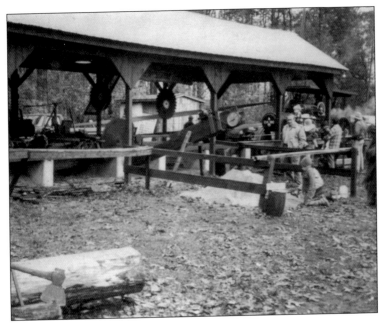

Sawmills were a significant component and occupation in the town, certainly enough to be immortalized on the official Paramus seal. Sawmills were one of the earliest industries in the Paramus area. There were at least two recorded mills established before 1745, Zabriskie Mill and Red Mill, which was located on the southwestern section of the Arcola section.

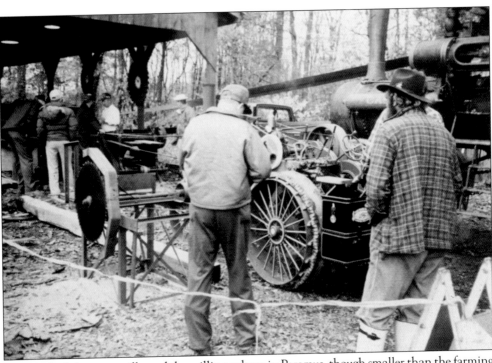

Paramus had three sawmills, and the milling culture in Paramus, though smaller than the farming community, was very active in the first half of the 20th century. The lumber cut in the mills was used, primarily by farmers, for building houses, furniture, tools, or for firewood. Some of the wood was cut into railroad ties and so was bought and used by the railroad industry in Paterson, a nearby town.

Four

GROWTH OF THE BOROUGH

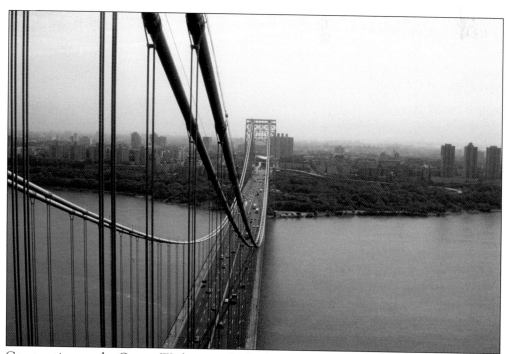

Construction on the George Washington Bridge began in 1927 and was finally opened to the public in 1931. Many Paramus residents commuted to the Hudson River daily to work on its construction, which was fitting, considering George Washington's history of involvement in the Paramus area.

In the early 1900s, the only public transportation in Paramus was the Hudson River Trolley that traveled from Paterson to Hackensack on the border of what is now Paramus and Rochelle Park. Students that lived on the east side of Sprout Brook would use 3¢ tokens to take the trolley to Hackensack High School, while students west of the brook went to Ridgewood High School. The last trolley train ran in 1938 as the community adapted to automobiles and buses.

State Highway Route 2 was constructed in the early 1930s by workers from Paramus and surrounding towns, with funding from the New Deal. It is almost exactly parallel to Sprout Brook, the stream that divides Paramus in half. The highway name changed in 1937, and it is now known as Route 17, one of the major highways running through Paramus.

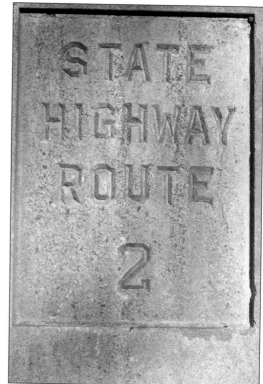

In the early years, Route 17 had grass dividers and u-turns. As more and more businesses moved onto the highway, these grass partitions were turned into additional lanes. As seen here, though, the one thing Route 17 always had was traffic.

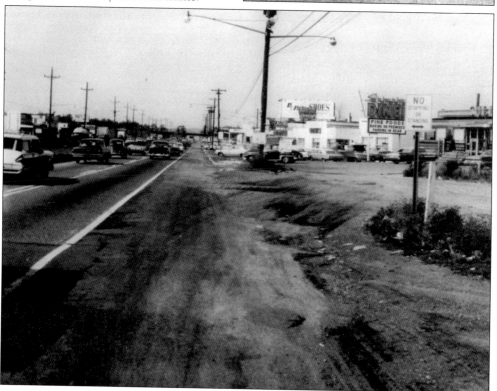

In 1931, at the height of the Great Depression, the New Deal spurred the Public Works Administration to build highways across the nation. Highways 4 and 17 were a result of the government projects before and during the New Deal. This sign was placed on a bridge on Route 4.

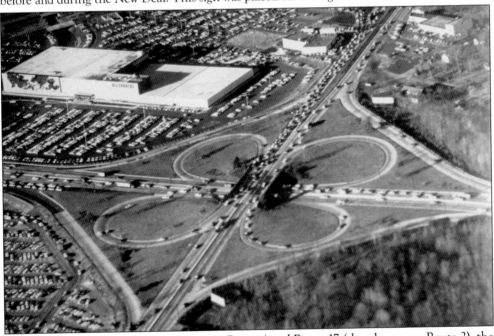

A cloverleaf was built as an intersection to Route 4 and Route 17 (then known as Route 2), the two major highways in Paramus. This intersection increased traffic in Paramus and officially pushed the once rural town into a more urbanized era. The land used to build the cloverleaf was originally sold for only $250 per acre.

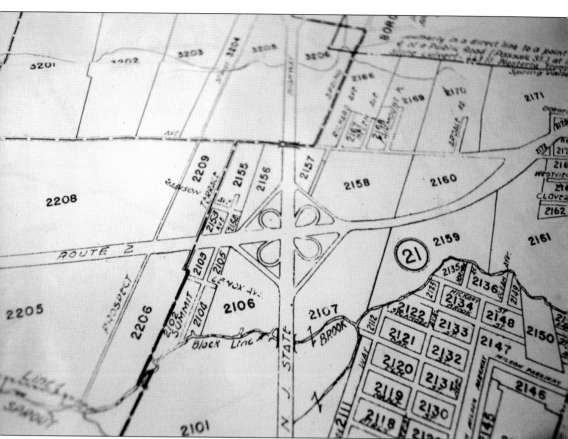

This 1937 Tax Assessor's map shows the distinctive cloverleaf shape as well as the name of Route 2. This map was created the same year Route 2 changed its name to Route 17. (Courtesy of the Tax Assessor's Office.)

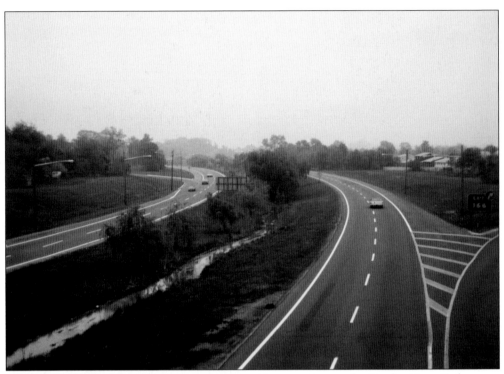

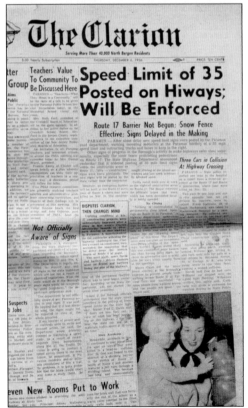

The Clarion

Serving More Than 40,000 North Bergen Residents

THURSDAY, DECEMBER 6, 1956 PRICE, TEN CENTS

Speed Limit of 35 Posted on Hiways; Will Be Enforced

Route 17 Barrier Not Begun; Snow Fence Effective; Signs Delayed in the Making

Construction on the Garden State Parkway, which runs 172.4 miles through the state of New Jersey, began in 1947. By 1950, only a fraction of its current length had been completed, and construction seemed to be at a bit of a standstill until 1952, when the newly created New Jersey Highway Authority was approved to plan and build the rest of the highway, which ran from Paramus to Cape May. Today, it is one of the busiest highways that runs through Paramus.

This newspaper article from the *Clarion* on December 6, 1956, discusses the various safety measures taken to lessen the danger of Route 17, including new signs enforcing a 35 mile per hour speed limit, a snow fence built to deter pedestrians, and "Slow–Construction" signs for construction sites. This speed limit seems almost quaint to Paramus residents now, who are familiar with Route 17's current speed limit of 50–55 miles per hour.

The Hudson Transit Short Line Bus System was introduced in the early 1930s, around the time that highway development made Paramus an accessible part of the New York metropolitan area. This system replaced the previous trolley system and ran from Paramus, Ho-Ho-Kus, Waldwick, Allendale, Ramsey, Mahwah, and other New Jersey towns into New York's Dixie Bus Center, Eighth Avenue Subway, Rockland Terminal, 181st Street and Amsterdam Avenue, and Times Square.

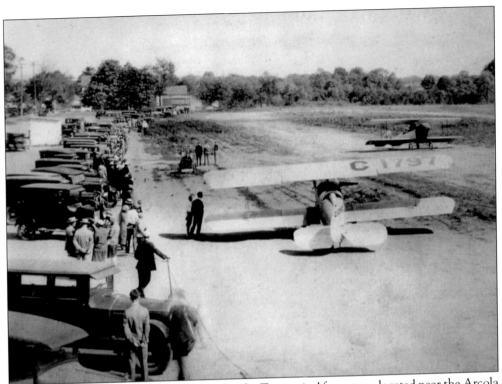

Trautwein airport, on land previously used as the Trautweins' farms, was located near the Arcola Amusement Park. It served as both a transportation airport, useful because of its proximity to New York City, and as a place where pilots could put on stunt flying shows for spectators. The airport shut down in 1929 because of the Great Depression.

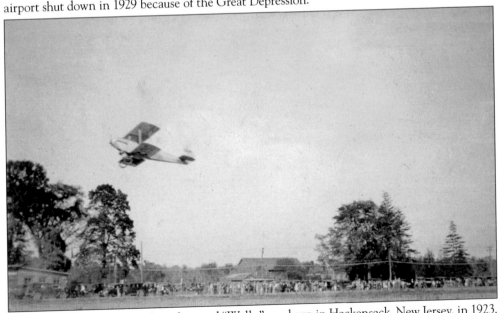

Walter Schirra, affectionately nicknamed "Wally," was born in Hackensack, New Jersey, in 1923. He was one of the original seven astronauts chosen for Project Mercury, America's first effort to put humans in space. He took his first airplane ride at the Trautwein airport.

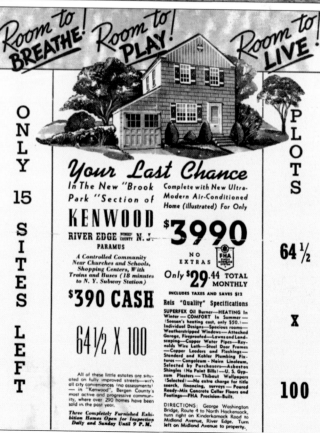

Housing developments began taking over in the mid-1950s as Paramus transformed from a farming community to a suburban town. Almost a textbook example of suburban sprawl, the housing developments shot up along with shopping centers, restaurants, and, of course, traffic. Some of the well-known developments in the area are the Reis home developments in the Kenwood section of Paramus, the developments in the Haase Avenue area, the Ridge Ranch homes, and the Paramus Modern Village, established after World War II. The new families in the Reis home development started a social club called the Kenwood Community Club. Each member would take turns hosting a party every so often at their homes. (Courtesy of the Tax Assessor's Office.)

67

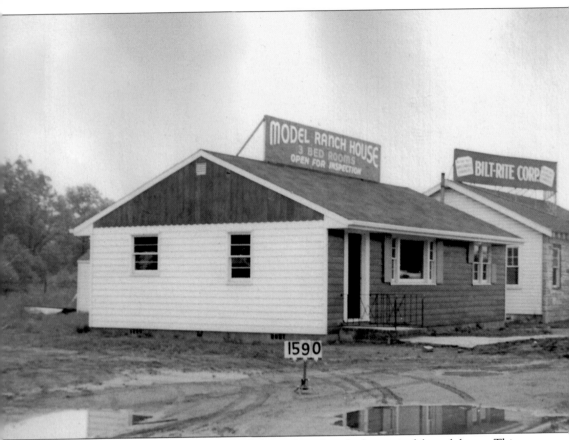

Shown here is an advertisement on top of a house for a three-bedroom model ranch house. This was taken in 1955 at the height of the town-wide construction of neighborhood housing expansions. Many housing developments assured buyers of the uniqueness of their development by stating they would alternate colors of the houses in a pattern—brown, white, green, or gray—ironically promoting the very suburban uniformity people were trying to branch away from. (Courtesy of the Tax Assessor's Office.)

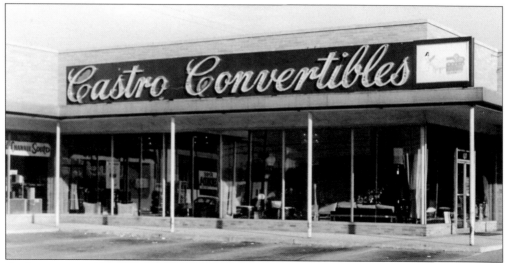

As the citizens of Paramus furnished their new homes, furniture stores like Castro Convertibles, which sold convertible sofa beds, opened their doors. Castro was notable for their television commercials and advertising campaign featuring the manufacturer's six-year-old daughter Bernadette, who illustrated for consumers that the convertible sofas were so easy to operate that a child could do it.

Pictured here is the corner of Farview Avenue and Lawrence Avenue in 1957. Fairview Avenue was one of the main roads in Paramus in the mid-1940s, along with Route 4 and 17, Paramus Road, Midland Avenue, Linwood Avenue, Ridgewood Avenue, Forest Avenue, Spring Valley Road, and Century Road. The increase of major roads in the area brought an increase in traffic and, unfortunately, a rise in traffic incidents. For example, there were many accidents over the years at the intersection of Century Road and Farview Avenue, but it was not until the 1950s that a traffic light was finally installed after a neighbor was killed. (Courtesy of Herb Carlough.)

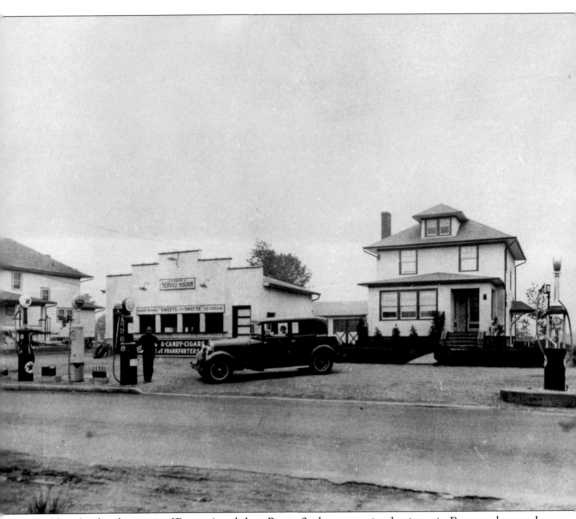

After the development of Route 4 and then Route 2, the gas station business in Paramus boomed. Gas only cost 24¢ to 30¢ a gallon in the 1930s. These service stations were unlike the corporation-based gas stations seen today; mom-and-pop gas stations like Ferber's, pictured above, sold multiple brands of gasoline, and customers could pick which brand they wanted.

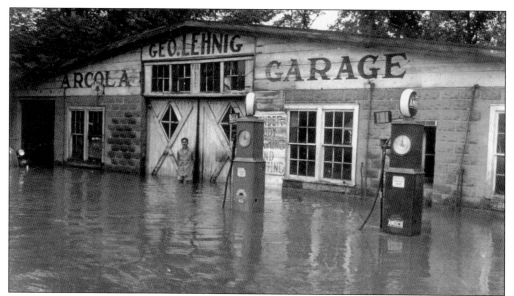

Due to the nearby streams and rivers, coupled with the East Coast weather, Paramus has seen quite a few floods throughout its history. In September 1960, Hurricane Donna hit Bergen County, knocking down trees and flooding basements and roads. During this time, the Paramus Rescue Squad rowed down the Saddle River to help evacuate residents in the area. Another big storm hit Paramus in 1999 when Tropical Storm Floyd caused extensive flood damage throughout the town. The recent Hurricane Sandy in October 2012 is also famous for its massive damage, closing dozens of roads and leaving thousands of homes without power.

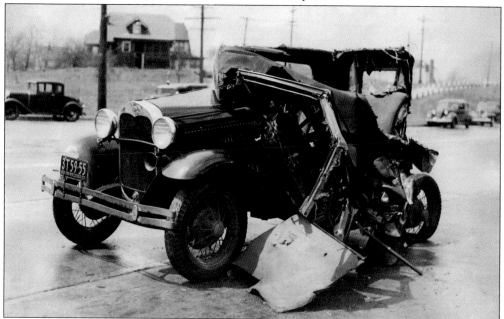

Policemen not-so-affectionately and colloquially referred to Route 4 and Route 17 as "Ulcer Alley," as the amount of accidents and traffic incidents were enough to induce ulcers. This particular accident involving a Model A Ford occurred on this aptly named area, as it happened on Route 2 South (now Route 17 South) at Farview Avenue.

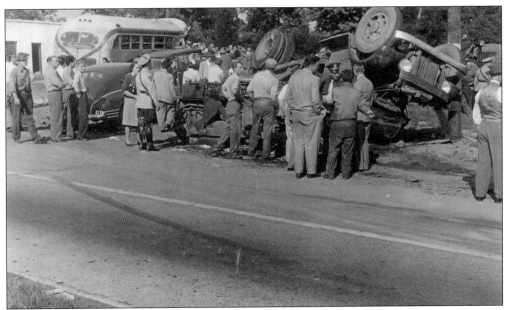

Car accidents, like fires, were very common in Paramus and, also like fires, usually attracted a large crowd of spectators. This accident occurred outside a bus depot, so the crowd was unusually large, as it included policemen and bus goers alike.

Traffic and accidents were the primary reason the police department had to expand. Keeping up with the increasing accidents and calls proved to be difficult with the limited number of policemen and automobiles the police owned themselves, so a new building and increased number of officers were immediately prioritized in the department from the 1930s through the 1950s.

On April 11, 1925, three years after Paramus was established as its own town, the Paramus Police Department was developed. It consisted of one man, Barney Martin, who conducted police business on his own front porch. Martin was the chief of police until 1935. He first used his own means of transportation until a police motorcycle was acquired for him.

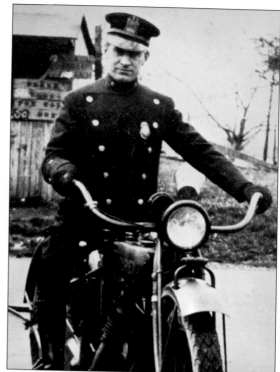

This familiar structure on Midland Avenue has served quite a few functions over the years as the community's oldest continuously used public building. Built in 1876, it was one of the first schoolhouses in Paramus. In 1924, after a four-room schoolhouse was built next door, the building became the borough hall. The police department was housed in the basement, with a vault and a jail, until 1958, when the police moved and the building became a public library. (Courtesy of George Egley.)

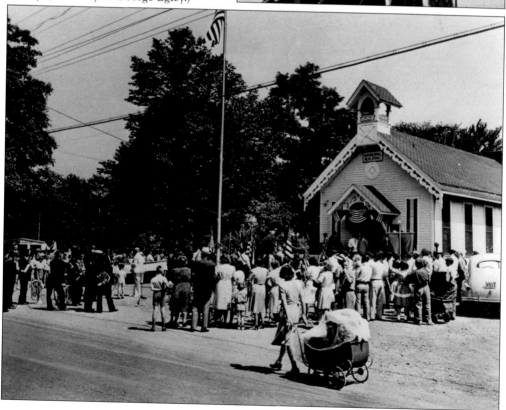

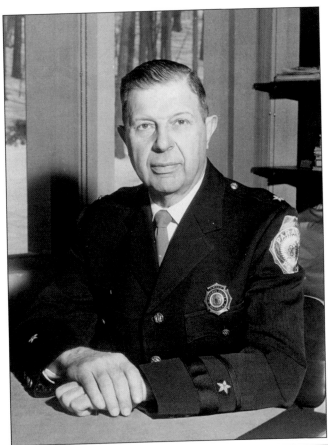

Carl Jockish was the second police chief in Paramus, succeeding Barney Martin in 1936. Jockish gracefully handled Paramus's transition from farming community to shopping hot spot and the increasing demand of police officers for increasing crime and traffic. During his term, he even oversaw the construction of a new, modern police station, as the makeshift police station on Midland Avenue was not equipped to handle the department overhaul. The department flourished during his time as chief.

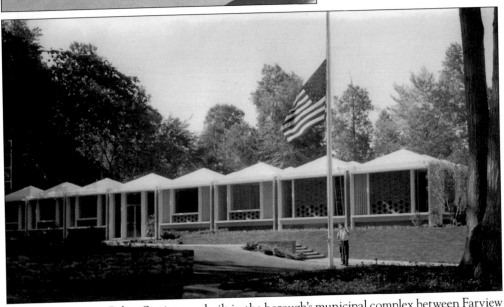

The newer Paramus Police Station was built in the borough's municipal complex between Farview Avenue and Route 17 where it currently stands today. The department handles over 60,000 calls for service each year and is dedicated to protecting Paramus's half-million visitors each day.

Pictured here is Fred Rapp, who was a cherished patrol sergeant and patrol lieutenant from 1936 to 1962. One Paramus resident recalls one winter when a neighbor was complaining about kids sledding down the hill in front of her house. Rapp showed up at the hill, borrowed one of the kids' sleds, got to the bottom, gave it back, and simply left.

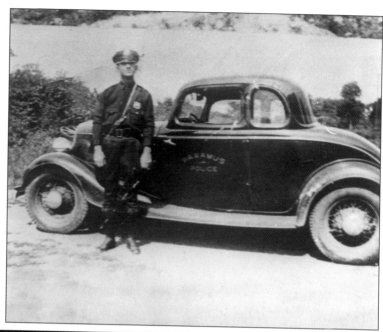

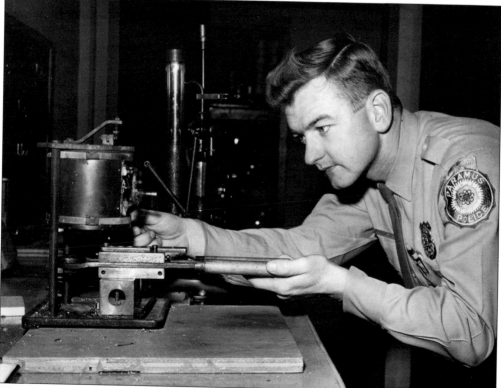

The process of pouring and making lead bullets can be dangerous because of the noxious fumes and high temperatures. However, it was fairly standard for police departments to make their own bullets for the majority of the 20th century. Paramus police officer Donald McNair is seen here at work in the armament room, pouring lead for bullets at the Paramus Police Station in 1963.

The Paramus Fire Department has four fire companies: Company No. 1 on Firehouse Lane near Ridgewood Avenue, Company No. 2 on Spring Valley, Company No. 3 on Midland Avenue, and Company No. 4 on Farview Avenue. All firefighters are professionally trained volunteers, serving Paramus 24 hours a day, 365 days a year. The members of the fire department meet every Monday night, checking on equipment and training.

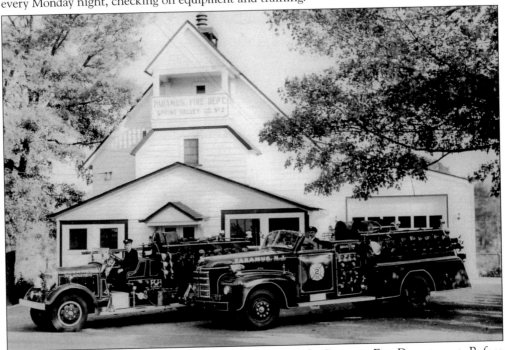

In 1935, the borough of Paramus finally agreed to fund the Paramus Fire Department. Before that, firemen had to buy their own suits, shoes, extinguishers, and even their own fire trucks for themselves.

Damaging fires were unfortunately common due to a lack of resources and fire hydrants. There were two big fires on Route 4 in the 1940s. One happened around Thanksgiving time in 1945 at the Dutch Mills Restaurant, and another took place at the Highway Furniture Store in 1947. The nearest fire hydrant at the time was in Maywood, a half-mile away. Additionally, the Arcola section of Paramus had so many fires that children would run around to find and watch the fires. The Arcola Amusement Park, for example, was burned to the ground.

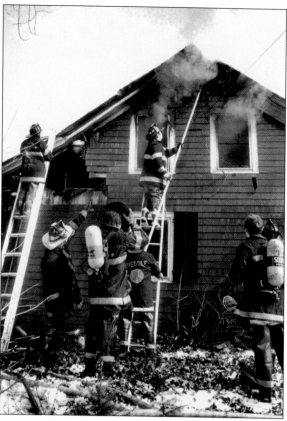

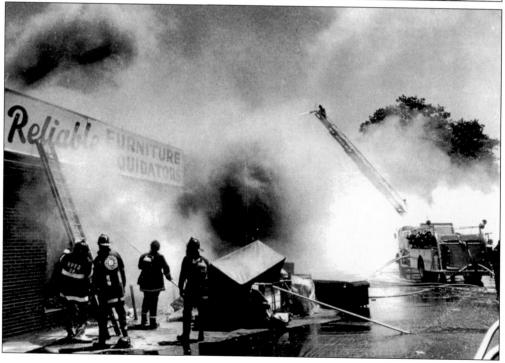

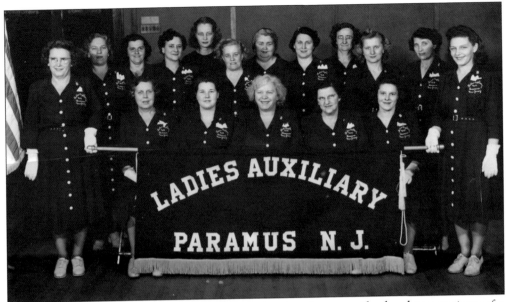

The Ladies Auxiliary of Paramus was an organization for any wife, daughter, or sister of a firefighter. The group supported the volunteers with refreshments, such as food and water, at major incidents.

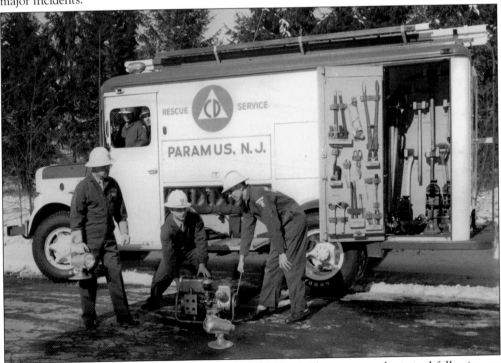

The Paramus Rescue Squad was formed in 1952 to prepare for rescue and survival following an atomic attack or war. Eight men were trained as specialists in 1956 by local, county, and state Civil Defense–Disaster Control officers. Two years later, the organization bought a rescue vehicle that was soon housed in a vacant garage on Midland Avenue. Over the next several decades, the rescue squad has responded to accidents, floods, tornadoes, hurricanes, and other calls of distress.

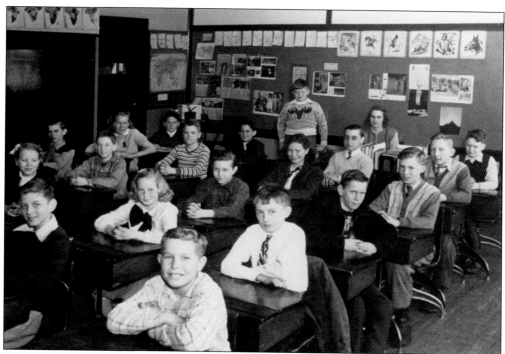

Although the English governed Bergen, Dutch continued to be the language of the home and was taught at school. The first school in New Jersey was established in 1662 in Bergen Township, now Jersey City. The first school in what is now Bergen County was built in 1730 in the old Paramus area, near the Old Paramus Reformed Church. Today, as it is presently in the borders of Ridgewood, this school functions as the museum of Ridgewood. The typical schoolhouse was one room with small windows. It was built with logs and clay and contained long boards as desks and long benches as seats. Children learned to read and write, and teachers often made their own arithmetic books.

In 1876, the building pictured here was constructed on Midland Avenue. Initially, it served the community as a one-room schoolhouse, but it soon became the borough hall. During its time as a schoolhouse, the well-known Emily Howland was a student and soon a teacher at this school in the late 19th century. Years later, the building was transformed into the Paramus police headquarters, captured in the image. Finally, in 1993 and 1994, the building was renovated and converted into the Charles E. Reid Branch Library as it stands today.

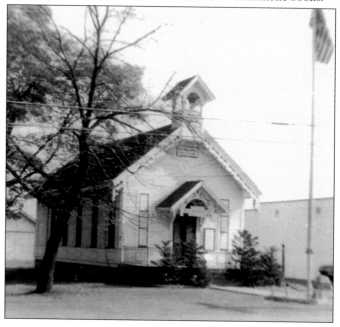

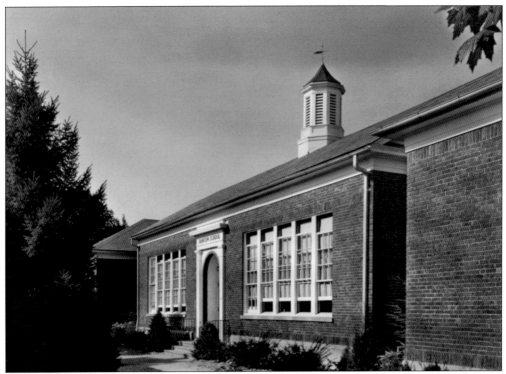

The Farview School was a four-room schoolhouse built in 1924. Leonora Lawrence served as the principal until the 1930s, when George Hodgins replaced her. The school stopped being used in the 1950s when the newer elementary schools were built. The building now functions as the Yavneh Academy, a Modern Orthodox coeducational yeshiva day school. Additionally, Paramus is home to two other Jewish schools: Yeshivat Noam and the Frisch School, a Jewish high school founded in 1972.

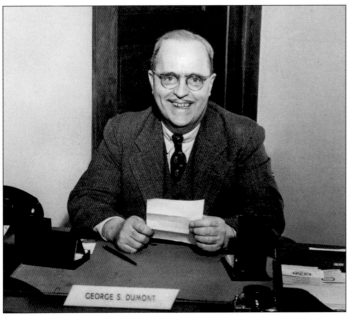

George Dumont was hired in 1926 as the principal of the newly built Midland Avenue School and worked until the 1950s. George Hodgins, not pictured, was hired as the principal of the new Farview School in the 1930s and, later, became superintendent of the entire Paramus School District. These two educators were instrumental in the development of the Paramus School System, and their names are still remembered today. (Courtesy of Louise Suppo.)

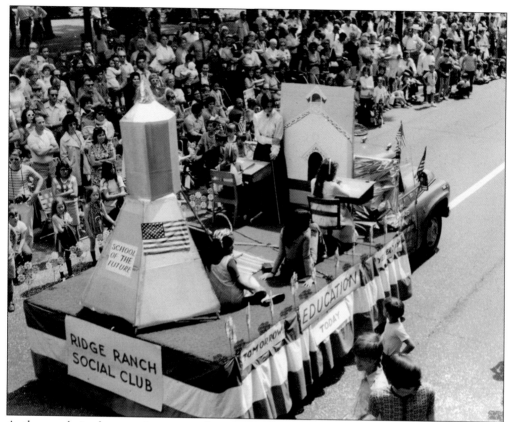

As the population began to increase in the town, more schools were needed. Today, to accommodate the school-age population of Paramus, there are five elementary schools. The first two of the five elementary schools were Ridge Ranch and Stony Lane, both built in 1954. Ridge Ranch was named a 1998–1999 Blue Ribbon School by the US Department of Education. Pictured here, a float made by the Ridge Ranch Social Club shows a rocket with a title "School of the Future." (Courtesy of George Egley.)

The third elementary school was Memorial School, which was built in 1950 on Midland Avenue between Farview Avenue and Forest Avenue. Parkway School was built eight years later, in 1958, on Ridgewood Avenue.

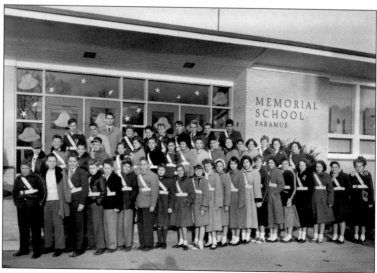

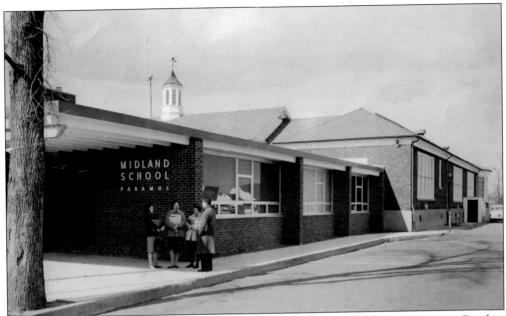

Pictured here is Midland Elementary School, built on Midland Avenue near Paramus Road in the mid-20th century. Due to a low enrollment, Midland School was closed in 1978 and reopened in 2000 after a renovation. There was also another school, Spring Valley School, that no longer stands today. It was opened in 1952 on Spring Valley Road near Forest Avenue. It was demolished in the early 1980s when the other schools were expanding and undergoing renovations.

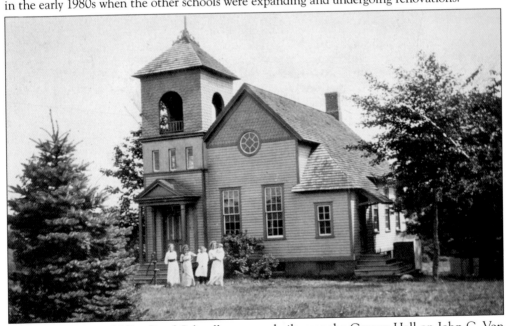

In 1894, the Spring Valley Road Schoolhouse was built near the Grange Hall on John C. Van Saun's property. This was one of three one-room schoolhouses where first graders to eighth graders attended prior to 1922. In 1924, construction started on the two new four-room schoolhouses on Midland Avenue and Farview Avenue, which made the one-room schoolhouses seem impractical for educational purposes. The schoolhouse was repurposed as a home shortly after.

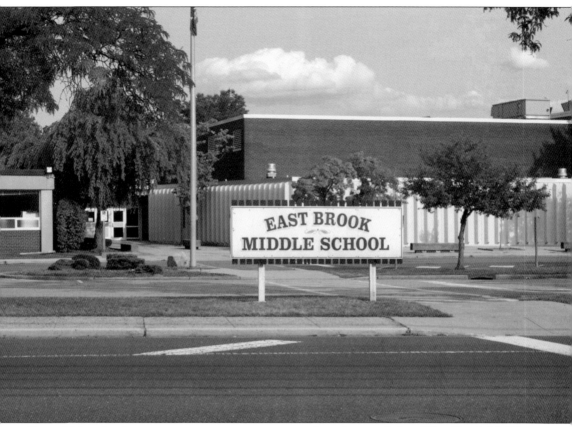

Two middle schools soon were necessary to accommodate the population. West Brook Middle School was built in 1960 on Roosevelt Boulevard, and East Brook Middle School was built in 1963 on Spring Valley Road near the high school. In 2007, a controversy hit the town when high levels of pesticides were found on the grounds of West Brook Middle School. Contamination of Paramus soil is not surprising, as the area used to be covered by farmland with a number of pesticides applied to the ground. However, the contamination was not reported for four months. West Brook Middle School was temporarily closed, as was the Paramus Pool that is located adjacent to the school, and students finished up the year at Bergen Community College.

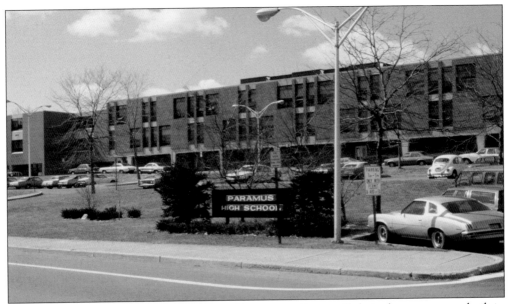

Paramus High School, the school that many Paramus residents call their alma mater, was built in 1957 on Century Road and Spring Valley Road. Before it opened, ninth-graders would go to the State Street Middle School in Hackensack. Grades 10 through 12 were at the Hackensack High School. All students living east of Route 17 went to Hackensack for the ninth through twelfth grades, and all students living west of Route 17 attended Ridgewood High School for the eighth through twelfth grades.

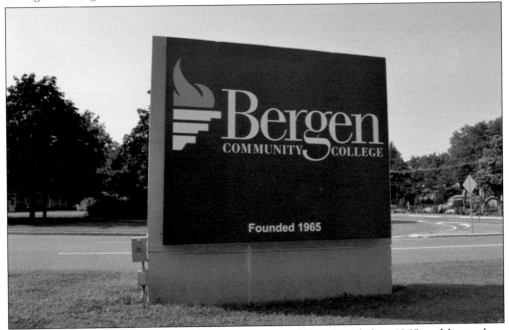

Bergen Community College is a public community college, founded in 1965 and located on Paramus Road. In addition to the main campus in Paramus, Bergen also has two other locations in Hackensack and Lyndhurst, educating more than 32,000 students in all. It is one of the top community colleges nationwide with a distinguished full-time and adjunct faculty.

In 1954, Paramus residents took action against the lack of books; there was no public library or bookstore in the town. The Paramus Public Library Association was formed to remedy this, and two small libraries, Howland Library and Midland Library, were established in 1955 and 1958, respectively. It was not until 1964 that a new library building was constructed on East Century Road, and when it was, it became the Paramus Public Library, pictured above.

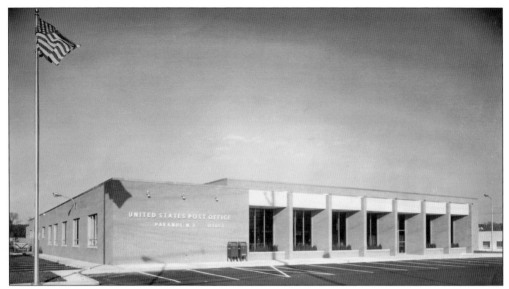

The Paramus Post Office is located on Midland Avenue near the Route 17 overpass. The first post office was located on the corner of Spring Valley Road and Howland Avenue at the turn of the 20th century. It was closed shortly after it was opened due to a lack of resources. For the next 50 years, Paramus did not have a post office and residents had to receive their mail from neighboring towns such as River Edge and Hackensack. In 1952, a new post office was opened and was located on Farview Avenue and Carlough Drive, currently the present site of the Cipolla Senior Citizens Center. After this location closed down, the current Midland Avenue building was opened.

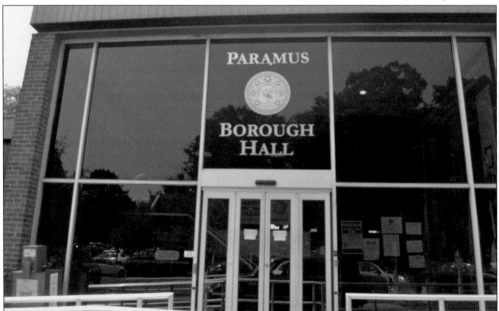

Borough hall, pictured here, is the Paramus Borough Hall, just one of the many buildings in the Paramus Municipal Complex, located in between Route 17 and Farview Avenue on Jockish Square, built in the late 1960s. The building houses the municipal court, along with offices for many other departments. Nearby is the Paramus Police Department, the rescue squad, the Department of Public Works, and the life safety complex.

Five

COMMERCIALIZATION

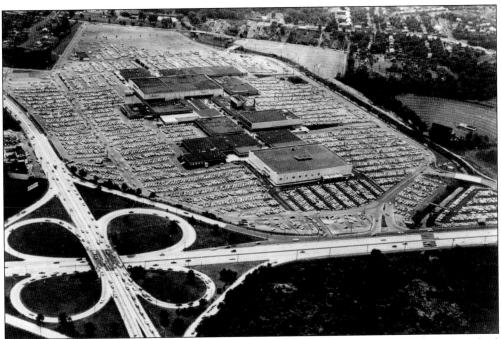

Shown here is the Garden State Plaza (GSP), found next to the Routes 4 and 17 cloverleaf. Although the cloverleaf pictured here has been reconstructed to help traffic move more smoothly, the plaza stands strong. In the winter shopping months, Paramus welcomes more than 200,000 cars a day. Additionally, the town generates about $5 billion a year in retail sales.

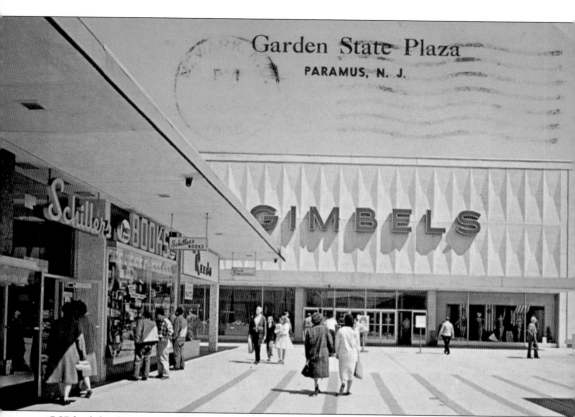

GSP had the distinction of being the very first mall of New Jersey, although it was not the only mall for very long. A year later, Bergen Mall opened, and Paramus Park Mall and the Fashion Center followed many years later. Garden State Plaza is identified as being one of the 30 biggest shopping centers in the country, and the 07652 zip code is associated as one of the most commercially viable zip codes in the country because of it.

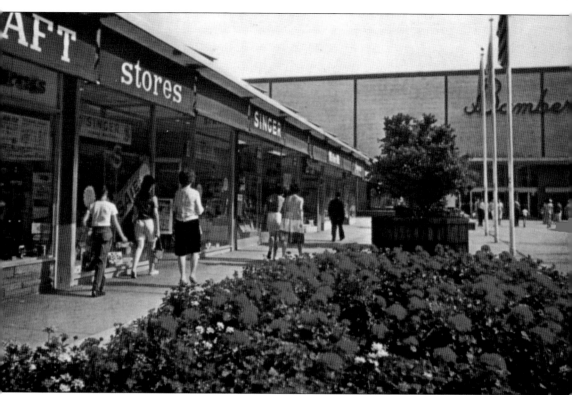

Opened in 1957 as an outdoor mall at the intersection of Route 4 and Route 17, the Garden State Plaza included stores such as Gimbels, Lorrys, J.C. Penney, and Bambergers. The outdoor mall included flower fixtures, seen here, but the mall was enclosed in 1980 and remodeled in the late 1990s. Today, with more than 300 stores and a 16-screen AMC move theater, the plaza attracts thousands of visitors daily from the New York City metropolitan area.

Construction of Six Million Paramus Business Center To Begin This Summer

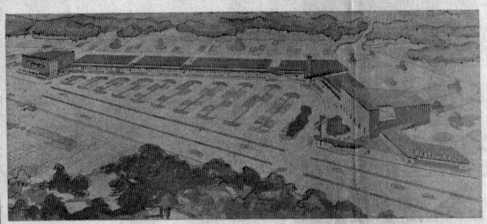

Construction of the $6,000,000 busines center on the N. T. Hegeman Co. property at Route 4, Paramus is scheduled to begin during the summer, Irving A. Germain, president of the company, disclosed this week.

The 50-acre site, located on the northerly side of Route 4 between Forest Avenue and Main Street, North Hackensack, is the heart of an area that has 750,000 residents within a 7-mile radius. The new State Parkway, Route 101, already legislated and soon to reach construction stages, will skirt the westerly end of the shopping center, and vastly increase the present 23,000-car daily traffic flow along Route 4.

Scientifically planned off-street parking, computed on a formula of 3 square feet of parking space to each 1 square foot of retail floor space, is designed to accommodate 2,500 cars.

One of the better New York department stores will occupy the large building at the westerly end of the site. The shopper, walking under a continous marquee, will have available 5 large chain store super-units, including a 5-and-10, a food market, a pharmacy, a furniture store, a personal service unit combining dry-cleaning, tailoring, laundering and shoe repair, and a 2,000 seat movie. In addition, there will be a restaurant, a nursery-florist, a bank and professional offices, as well as 30 smaller retail stores of every variety.

Although the project is unique in the New York metropolitan area, a similar center exists in the vicinity of Boston, while a $14,000,000 shopping center, Hampton Village, is now under construction in St. Louis. The Hampton Village super grocery market, already in operation while the remaining construction in under way, last year grossed $3,500,000.

Together with the projected New Jersey Sports Arena, a stone's throw away, the projected Paramus shopping center is expected to make this corner of Paramus the heart of Bergen County business activity.

Easily reached from every part of Bergen County, Paterson, Passaic and Clifton, as well as parts of Hudson and Rockland Counties, there will be a modern bus station on the property.

Mr. Germain, who resides in Teaneck, and Lawrence Germain vice-president of the company have continued the tradition, established by their late father, of sound, progressive real estate development in Bergen County. Like the St. Louis center, plans for which were conceived 18 years ago, the Paramus center is the result of years of far-sighted design and planning.

The Alexander Summer Co., of Teaneck and Fair Lawn, largest real estate organization in the County, is the exclusive renting and managing agent.

One of the nation's leading firms in the design and construction of shopping centers, super markets, hospitals, schools and large scale housing projects—Kelly and Gruzen, of New York and Jersey City—are the architects. Michael M. Burris and Associates, of Englewood, are the consulting engineers.

This article about the Garden State Plaza, published in 1948, nine years before the mall actually opened, discloses that the plans for the $6 million business center were about to enter the construction stage. The rest of the article mentions that the parking lot is constructed to hold 2,500 cars and that the mall is unique not only to New Jersey but to all of the New York City metropolitan area.

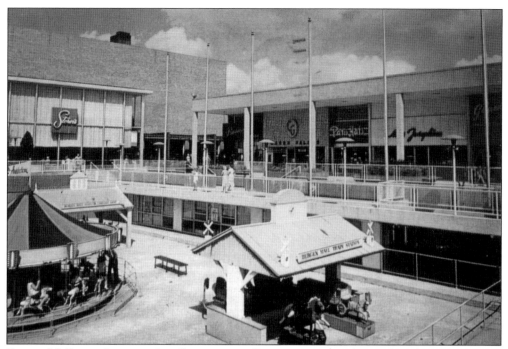

Bergen Mall was the second mall to open in Paramus; it opened in 1958. There were many attractions, including a theater, Kiddie land (pictured here outside of the main mall area), a chapel, and a bowling alley. The Bergen Mall was one of the stopping points in the 1960 presidential campaign; John F. Kennedy made an appearance in 1959, and vice president elect Lyndon B. Johnson also visited the mall, not two weeks later.

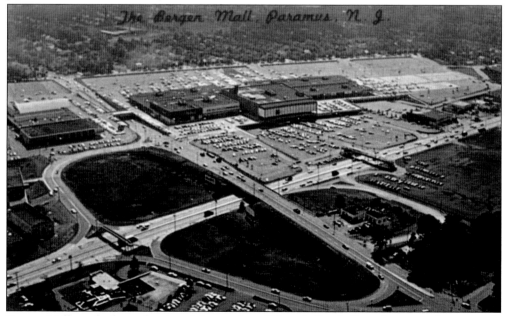

Bergen Mall was built on the site of the previous D'Angelo family farm. It was a prime example of how sudden the transition in Paramus was from agricultural to commercial. In the span of two years, Paramus had two vast shopping centers and thousands of visitors a day.

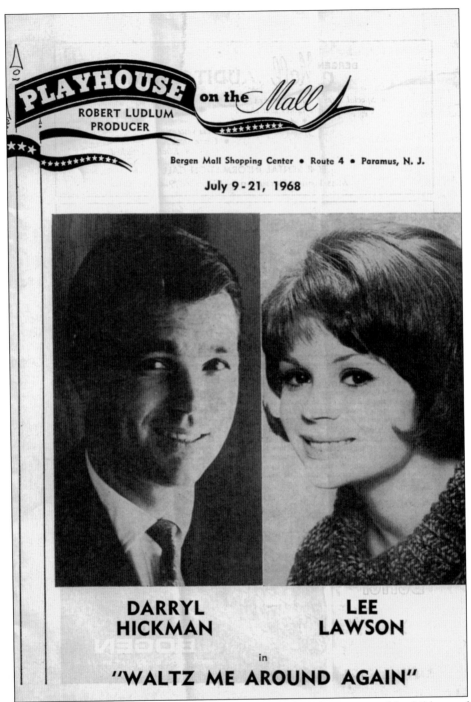

PLAYHOUSE on the *Mall*

ROBERT LUDLUM
PRODUCER

Bergen Mall Shopping Center • Route 4 • Paramus, N. J.

July 9 - 21, 1968

DARRYL HICKMAN LEE LAWSON

in

"WALTZ ME AROUND AGAIN"

Here is a playbill of *Waltz Me around Again*, starring Darryl Hickman, a notable child star of the 1930s and 1940s, and Lee Lawson. It was performed in the Playhouse in the Mall at Bergen Mall. The producer, credited in the top-left corner, is none other than Robert Ludlum, noted author of books such as the Bourne series, including *The Bourne Identity*, *The Bourne Supremacy*, and *The Bourne Ultimatum*.

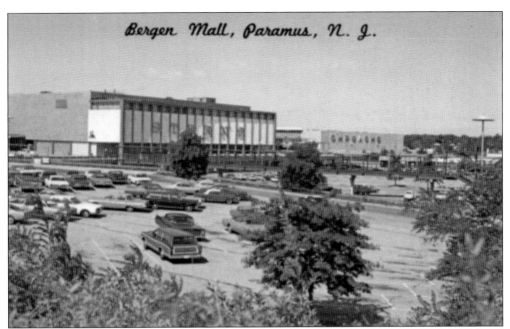

Bergen Mall, Paramus, N. J.

This postcard of Bergen Mall illustrates that the mall contains over one million feet of retail selling space and has a traffic count of 155,000 to 220,000 visitors weekly. The card also advertises the stores it contains, such as JJ Newberry's, Stern's Department Store, Ohrbach's, and other food, drug, variety, clothing, furniture, gift, and specialty stores.

This article advertises the Bergen Mall shopping center, built by Allied Stores Corporation in 1958. John Graham, of John Graham and Company, Architect-Engineers, is seen here inspecting an early scale model of Bergen Mall. At the time, there was only one main street to generate heavy shopping traffic, creating a parklike atmosphere.

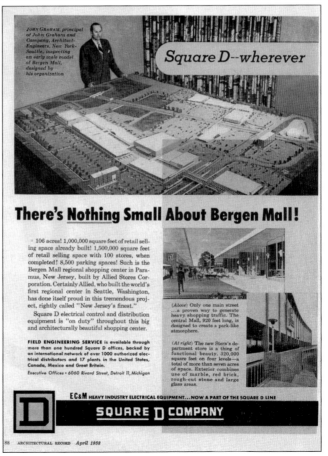

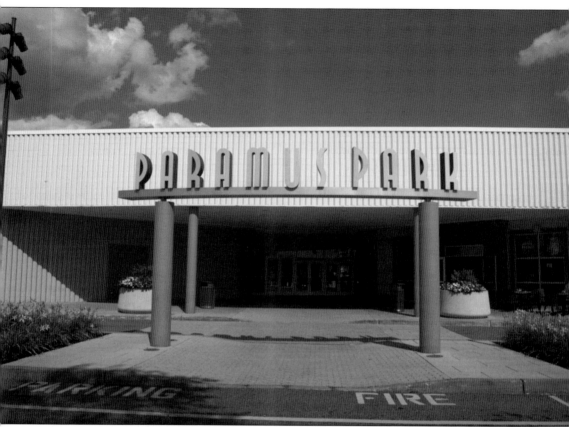

Located on From Road between Route 17 and the Garden State Parkway, the Paramus Park Mall is a two-floor shopping center that opened in March 1974. With more than 100 stores, a center fountain, and a food court, residents enjoy the relatively quiet atmosphere as they shop from one end to the other. A fourth mall in addition to the Bergen Mall, the Garden State Plaza, and the Paramus Park Mall is the Fashion Center, which was opened in 1967 on Route 17. After a decline in the mall's sales with the growing competition of the other shopping centers in the area, the Fashion Center was converted into a collection of separate stores with their own entrances.

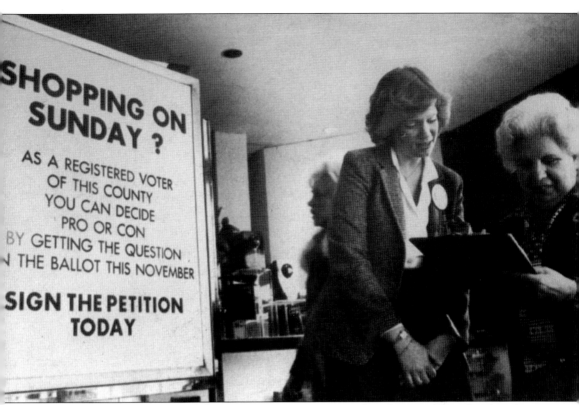

Blue laws, or Sunday laws, prohibit certain items or services from being sold on Sundays for religious purposes. Most blue laws have been repealed in the United States, but Bergen County has upheld them because of its excessive traffic and is the strictest in the country in its ban on the sale of clothing, furniture, and other items. Paramus has even stricter rules, allowing only restaurant and food services, gas stations, entertainment-like movie theaters, and hotels to remain open. Paramus residents, pictured here in the 1980s, voted on the issue again, deciding to keep its unique blue laws the same.

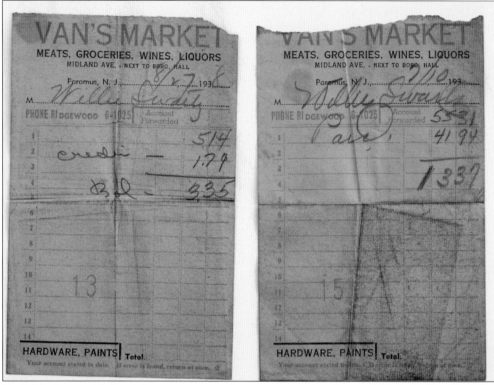

Van's Market on Midland Avenue, next to the one-room schoolhouse/Charles E. Reid Library, was one of the few combination grocery/butcher shops in the area. They ran on a system where anyone could charge their bill, and it would go "on the books" to be paid later. At one point, customers could not keep up with payments and Van's Market was so in debt, the only solution was to erase the old bills and make the farmers pay cash only—and insisting on a name change to Van's Cash Market to emphasize the policy change. The name also changed to Johnny's Cash Market and Vesuvio's before the shop became a small office building.

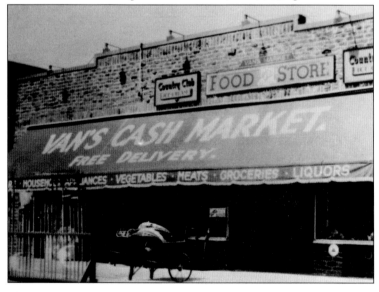

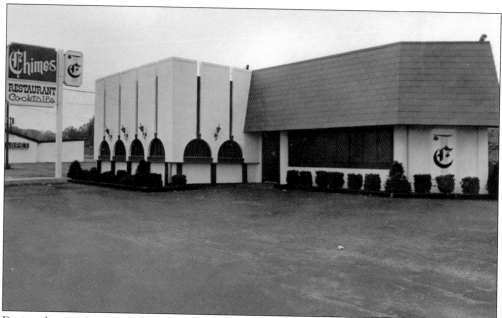

During the time Paramus was still considered the countryside, restaurants were few and far between. In fact, when families went out for a day trip in their cars, they made sure to pack enough food to last, as they did not know when or if they would encounter a restaurant. That soon changed, however, as commercialization in Paramus boomed and restaurants appeared everywhere. The popular Chimes restaurant is pictured, though it is no longer in existence.

The Suburban Diner, a central dining location in the Paramus community, opened in 1956. The structure itself was entirely moved to serve as a different diner in New York State, but the business remains active today in a different, bigger building.

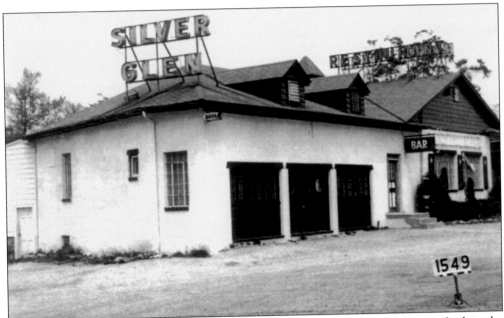

Two popular nightclubs, Gorman's Silver Glen (pictured here) and the Eldorado, were built in the early 1930s, right before Route 4 was constructed, in the Arcola neighborhood. The nightclubs often employed various entertainers and acts, such as singers, dancers, and bands. One of the entertainers who frequented both nightclubs was fondly remembered for owning a walking cane containing a sword. (Courtesy of the Tax Assessor's Office.)

This tiny building housed Stuart's Candy Store at Farview Avenue and Century Road. Candy stores like these were hit hard during World War II, as sugar was one of the food items most affected by the strict rationing. Sugar stamps were available in a person's ration booklet, and the sale of pounds of sugar was regulated from 1942 through 1947. Shortages in sugar made it necessary to continue the practice even after the war was over. (Courtesy of the Tax Assessor's Office.)

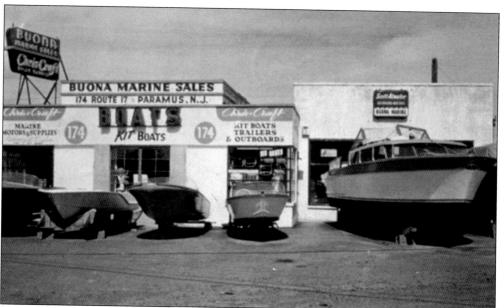

Pictured here is Buona Marine Sales, which once stood on Route 17; it was one of the many businesses that catered to nautical affairs. Paramus is not too far from quite a number of marinas and beaches, including the famous Jersey Shore beaches that are only a drive away down the Garden State Parkway. However, even though the beaches may be close, the traffic can be endless.

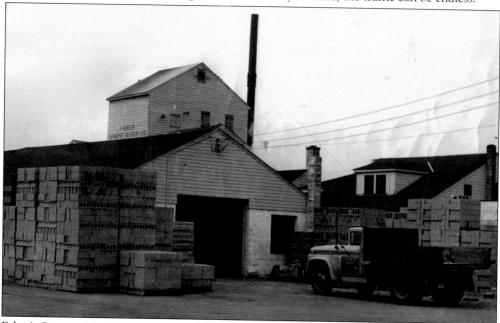

Faber's Cement Block Company was the modernization of the prominent milling community in Paramus. Faber's sold wood and lumber as well, but it was more successful in its sales of cement blocks; the housing development movement in the 1950s and general increase of businesses and buildings created a huge demand for building supplies. Many farmers, as farming was declining in the community, made the switch to construction, including the Behnke family, who own the Paramus Building Supply, still active today.

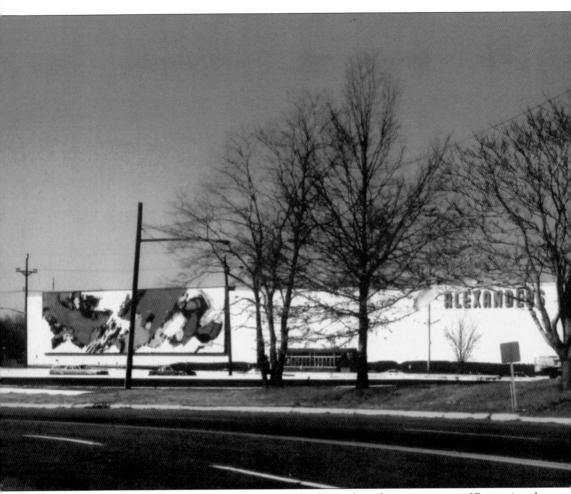

Opened in 1961, Alexander's was a department store located on the intersection of Route 4 and Route 17 in Paramus. Founded by George Farkas, Alexander's sold discount merchandise. However, for those who drove through Paramus, it was most famous for its 200-by-50-foot mural, an abstract piece created by the painter Stefan Knapp. After the store closed in 1992, the artwork remained on the building for four years until the 280-panel mural was moved to a warehouse in Carlstadt. The store was demolished and replaced with an Ikea.

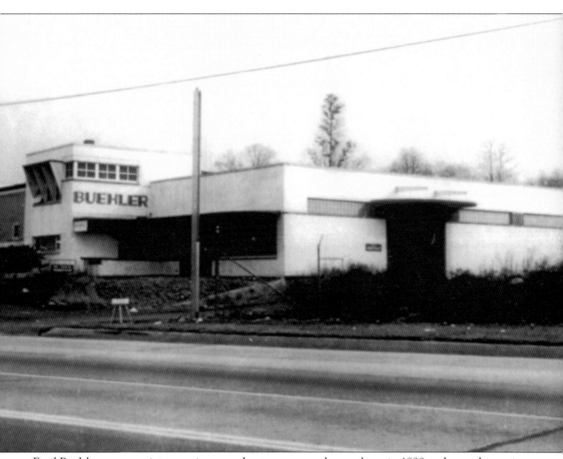

Emil Buehler was an aviator, engineer, and entrepreneur who was born in 1899 and passed away in 1983. The structure above is one of his engineering office buildings. His name is most recognizable to Paramus residents as the prefix to the Buehler Challenger & Science Center.

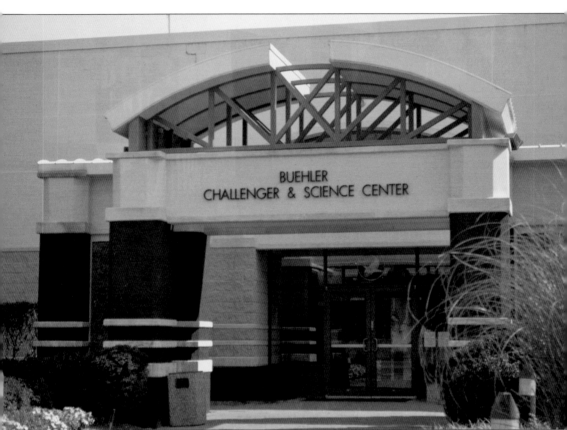

The Buehler Challenger & Science Center was made possible and funded by the Emil Buehler Trust. Paramus's challenger center, established in 1994, is one of many challenger centers across the country that honors the crew of the Space Shuttle *Challenger* disaster of 1986. The center today hosts field trips and summer camps that promote education in science, technology, engineering, and mathematics.

Six

COMMUNITY AND RECREATION

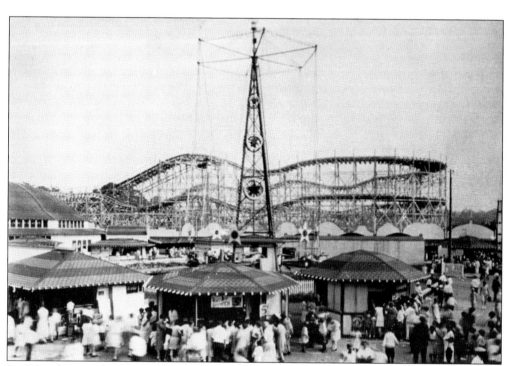

In 1926, the Arcola Amusement Park was built in the Arcola area between Rochelle Park and Paramus. Among the attractions on the 20 acres of land were the carousel, a Ferris wheel, a roller coaster, the whip, a swimming pool, and an auditorium. As seen here, the roller coaster was a popular attraction.

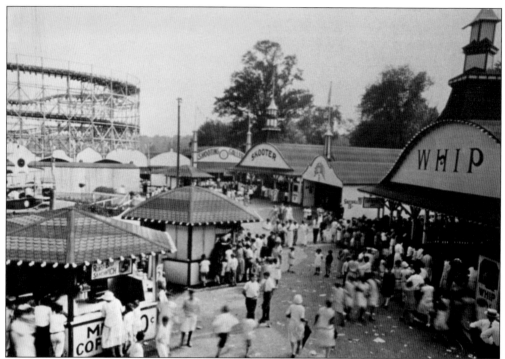

Unfortunately, the Arcola grounds were susceptible to many fires, and the amusement park was lost to a fire in 1929. The swimming pool was the only attraction that could be salvaged, and it was used as the Arcola Swimming Pool for many years until the 1970s, when it was also lost to a fire.

The Arcola Convention Hall was built in 1926 and was part of the Arcola Amusement Park grounds. All of Bergen County used the hall for events, like conventions or boxing matches. However, the run as the county's primary convention hall was short-lived; unfortunately, it also perished in the 1929 fire that destroyed the rest of the amusement park.

Also on the site of the Arcola Amusement Park were the Arcola picnic grounds. From 1926 to 1929, the grounds were very popular whenever there was warm weather. Note the dress etiquette; by today's standards, the children playing on the grounds look more appropriately dressed for church.

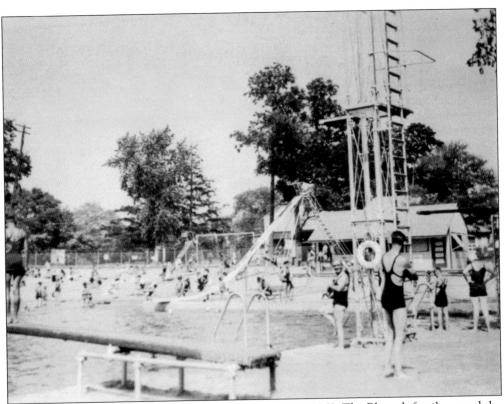

The Paramus Bathing Beach opened in 1932 and closed in 1962. The Blauvelt family owned the property, and the DeGeeter family conducted most of the business aspect of the pool, which could accommodate around 2,000 people and had underwater lights so swimming could be continued even when it was dark out.

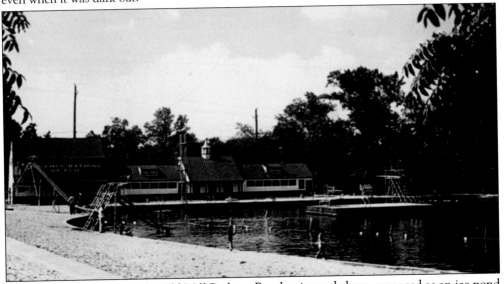

In the early 20th century, the Old Mill Bathing Beach, pictured above, was used as an ice pond by the Blauvelt family. The water was used to cultivate ice blocks in a time when iceboxes were used instead of refrigerators. The pond later turned into a recreational pool.

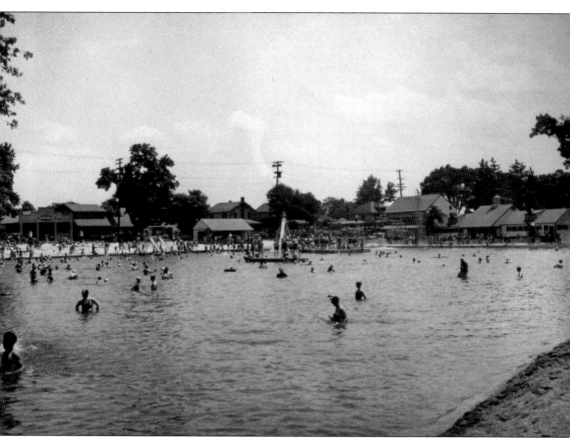

There was a slight cultural division when it came to these types of bathing beaches, considering most farm families still swam in brooks, rivers, and natural ponds. Paramus still had a largely agriculturally influenced culture in 1932, and these farm families thought that only "city slickers" went to the new bathing beaches.

The Old Mill Bathing Beach was one local swimming attraction for Paramus residents. After daylight hours, it was also popular for dancing, listening to music, and having parties. The police were occasionally called due to noise complaints. The land surrounding the swimming pool was eventually sold and is currently vacant, despite the "Open for Public" sign still in front. The area was used in an episode of the popular television series *The Sopranos* in 2000. (Courtesy of the Tax Assessor's Office.)

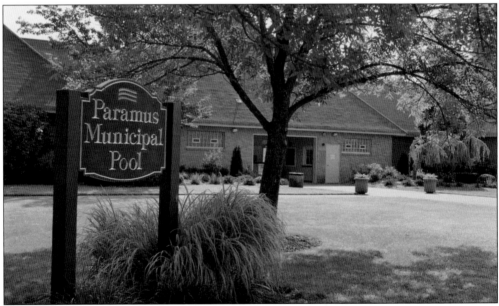

The Paramus Municipal Pool is an outdoor pool facility that was built in 1964 close to Midland Avenue. There are three swimming pools: the main pool, which has three diving boards and a water slide; the intermediate pool; and the kiddie pool. The facility consists of a snack bar and an eating area, a volleyball court and shuffleboard, large grass and recreation areas, playgrounds, and shade tents. The pool has a competitive summer swim/diving team called the Paramus Pacers, and private lessons are available as well. There are also various special events during the summer such as preteen nights, family days, and senior citizen days. It serves as a place to gather with friends and family and enjoy the hot summer days.

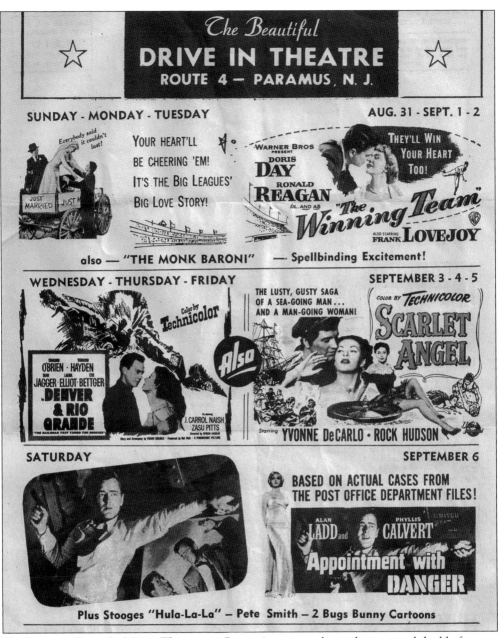

The Paramus Drive-In Movie Theater, on Route 4, was popular with its typical double features during the 1950s and 1960s. It closed in the late 1980s, and the spot was converted into a parking lot for the Garden State Plaza. This particular drive-in program shows the variety of films that were viewed there—from the romantic *Scarlet Angel* to the classic baseball story in *The Winning Team* to the family-friendly Bugs Bunny cartoons.

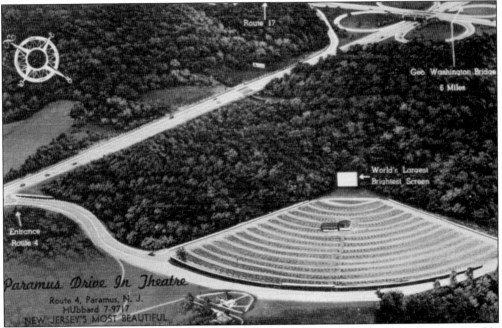

Shown here is a postcard advertising the Paramus Drive-In Movie Theater as having the "World's Largest Brightest Screen," as well as the theater's proximity to Route 4, Route 17, and the George Washington Bridge. The movie theater was popular and centrally located, providing a nice outdoor community space in the summer and a heater for each car's passenger's side in the winter.

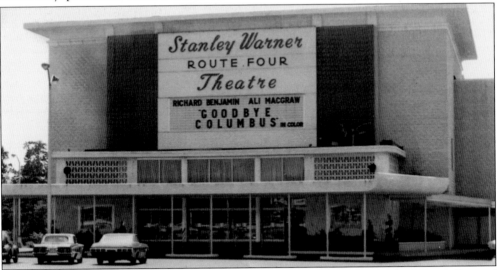

The movie theater on Route 4 near the Bergen Mall was opened as the Stanley Warner Route 4 Theater in October 1966. Designed by architect Drew Eberson, the theater was 50 feet high with 1,908 seats and faced the busy highway. When it was first opened, it showed three-strip Cinerama/Cinemiracle, and later in the 1970s, the theater showed 70mm. Over the years, there were several renovations. When a floor was added, the original balcony in the large theater became a second theater, and the lower level was split into two. By the time AMC Loews bought the theater, it had become a "tenplex." The theater closed in May 2007 just before the AMC Garden State 16 Theater was built in the Garden State Plaza.

The AMC Garden State 16 Theater opened in 2007, just after the Route 4 theater was closed, on Memorial Day weekend. This 16-screen megaplex was a large addition to the Garden State Plaza, proving to be successful in attracting visitors from all over the area. Other theaters in Paramus were the Paramus Picture Show and the Century Theater. The Paramus Picture Show was opened in 1972 on a strip mall near the intersection of Routes 4 and 17, seating a little over 300 people. The Century Theater was first opened at the Garden State Plaza in the 1960s. The two theaters closed in 2004 and 2006, respectively.

Music has always been an important part of Paramus culture. The glam rock band Trixter, popular in the 1990s, was formed by four of the town's residents, and Dean Friedman, best known for the 1977 hit "Ariel," included lyrics in his song about a girl "standing by the water fall in Paramus Park" and references the town as the "bosom of suburbia." (Courtesy of the Tax Assessor's Office.)

Featuring America's Favorite Dessert

JAHN'S Ice Cream

SUNDAES, MONDAES, SHMUNDAES!
What's the difference? Try one and see!

BANANA SPLITS 65¢
SPECIALTY OF THE HOUSE

The Kitchen Sink	6.50
Everything else but—serves four to six	
Super Duper For Two	2.25
Too much for one—for two it'll do	
A Shissel	1.85
If you can't eat it, use it for washing	
The Bombshell	1.70
Blow yourself up	
Tall In The Saddle	1.60
Hi Ho Silver—Away	
Flaming Desire	1.40
A slow burn with a fast finish	
The Thing	1.20
We dare you to open it	
Boiler Maker and Helper	1.20
Finish this and you'll have muscles so big	
Nosher's Nightmare	1.10
Burp!!!!	
Wha Hoppened	1.00
Don't ask us	
Brooklyn Kibitzer	1.00
Shut up and eat	
Fer a 2¢ Plain	.02
(#"&'$?/) Special	1.00
Some people groan after this one, maybe you won't	
Screwball's Delight	.90
Drive you nuts and plenty of them	
Jahn's Special	.90
Made especially for you	
The Tree	.90
This one grows in Jahn's, not Brooklyn	
Rainbow Mountain	.75
Looks so purty	
Suicide A La Mode	.80
Why not end it all here, it's cheaper	
Pink Elephant	.75
This is not the kind you see on the walls	

Ice Cream	.35 per plate
Vanilla Chocolate Strawberry Coffee Lemon	
Cherry Vanilla Black Raspberry Pistachio	
Walnut Banana Butter Pecan	
Sundaes (any flavor)	.50
Double Sundaes	.70
Triple Sundaes	.95
Ice Cream Sodas	.35
Twosday	.75
Two Sundaes and a Soda	
Double Wallop (Any Flavor)	.75
What a Soda! (Nuf Said)	

A SHAKERFUL OF

Malted	.60	Malted Float .75
Milk Shake	.55	Milk Shake Float .70
Frosted	.70	Frosted Float .85

Served To You In The Shaker
We Mix 'Em In

DAIRY RICH DRINKS

Malted	.35	Malted Float .50
Milk Shake	.30	Milk Shake Float .45
Frosted (No Malt)	.40	Frosted Float .50
Extra Heavy Frosted		.75
(You'll need a spoon for this one)		

COOLERIZERS

Iced Drinks—Lemonade, Orangeade, Limeade		.25
Grapeade, .25 Plain Sodas, .15 Pink Lady, .30		
Grape-Lemonade, .30 Grape-Orangeade, .30		
Coca-Cola, .15 Cherry Smash, .15		
Root Beer, .15 Moxie, .15		
Fresh Orange and Raspberry Sherberts		.30
Sherbert Sodas and Frosteds		.35
Shaker Full of Frosted Sherberts		.50

Have you a yen for something real gooey?	
Tell us what it is—we'll make it!	
Finger Bowl	.90
Fingers in—Nose out	
Pistachio Di La Festa	.80
Per Te Paison	
Chocolate Pecan Shortie	.80
Harold Teen takes the blame	
Joe Sent Me	.70
Joe musta liked us—Thank him for us	
Delaware Square	.85
You get no run around, it's all square and a yard high	
Buster Brown	.65
An old favorite made better	
Pineapple Temptation	.50
For small fry, dowagers and sissies	
Cherry Delight	.50
Like cherries and good vanilla cream?	
Peach Melba	.50
Peaches and cream for those on a diet	
Chocolate Sprinkle	.50
You can get them anywhere, but not like this	
Nut Special	.50
Toothpicks will be served upon request	
Fruit Salad Sundae	.50
What's the use—It's good tho!	
Hot Maplenut Fudge	.50
A Vermont and Texas Combo	
Hot Coffee Fudge	.50
An Eye-Opener	
Pistachio Marshmallow	.50
Green with envy	
Hot Chocolate Fudge	.50
Papa Jahn's original candy recipe	
Hot Butterscotch	.50
We're not Scotch with it	
Marshmallow Nut Sundae	.50
As you like it	

Cover illustration is reproduced from original oil painting by Frank Jahn

printed by WILBERN COMPANY, N.Y.

Jahn's was an old-fashioned ice cream parlor in the mid-20th century with several locations in the New York City area, such as the one located on Route 4 on the border of Paramus and Fair Lawn. Although it no longer exists today, visitors recall ordering the "Kitchen Sink," a gigantic sundae with everything in it that could serve quite a few people.

One way to see almost every Paramus resident in one place is to attend the Fourth of July Fireworks Show. Families have the chance to lay down blankets and reconnect with old friends. The Fourth of July Fireworks Show in Paramus goes back to at least the 1950s, where it was held at the Memorial School field as well as the West Brook Junior High School's field. Since July 4, 2003, the fireworks show has been held near the Garden State Plaza. Today, the town welcomes the Paramus Community Orchestra to play before the show.

Wintertime each year in Paramus was rife with fun outdoor activities. Sledding, sleigh riding, and snowball fights were constant occurrences. The parks' basketball and tennis courts would usually flood and freeze in the winter, creating the perfect spots for ice-skating. At Van Saun Park, a park ranger would maintain a large barrel full of fire at the end of the lake so ice-skaters could warm their hands. Here, Howard Behnke is seen driving a tractor up Spring Valley Road and pulling, from left to right, Henry Behnke, Betty Behnke Weising, Elaine Stormes, and Violet Behnke Acker on a sled to Raymond Banta's home.

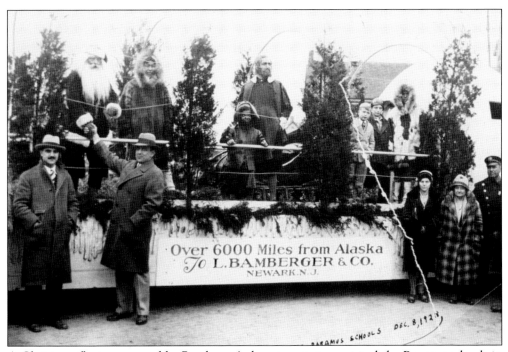

A Christmas float, sponsored by Bamberger's department store, visited the Paramus schools in December 1928. The float holds what appears to be a collection of statues depicting Santa Claus and several Eskimos and states, "Over 6,000 Miles From Alaska." Several Paramus students are pictured on the float itself toward the right side.

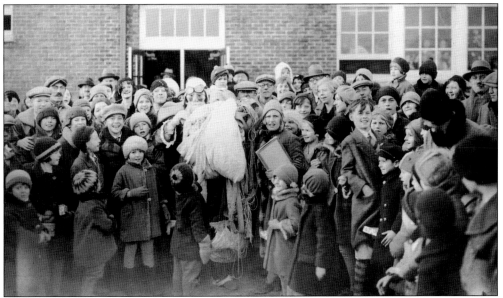

Besides being part of the annual Christmas float, Santa Claus would visit the schools from a parachute every year. Here, Santa is seen at Midland School in December 1930, surrounded by students and holding the parachute and parachute string in his arms. The man with the hat and moustache at the right of the photograph is Frank Flora, the superintendent of the schools, who was presumably trying to calm the hysteria amongst the students.

Recreation in Paramus was not limited to outdoors or physical activity. Here, the glee club at the Spring Valley elementary school can be seen practicing for the annual Christmas and holiday concert in the winter of 1952.

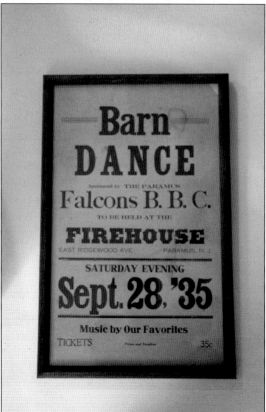

Dance was a surprisingly abundant pastime in Paramus. While it was still a farming community, barn dances, like this one, were very common and mostly featured square dancing as the most prominent style. A common location for these dances was Grange Hall. Even after Paramus entered its heavily commercial era, square dancing groups still existed and even toured different cities, states, and countries. Present-day groups probably wish they could go back to the time when barn dances only cost 35¢.

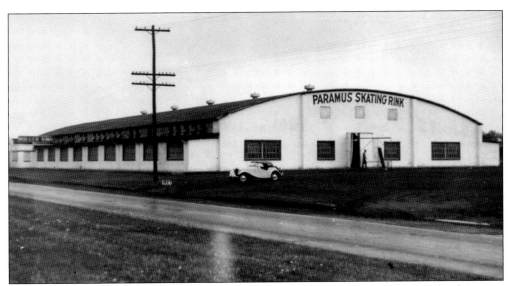

In 1937, the DeGeeter family built the Paramus Skating Rink on Route 17 by Midland Avenue with enough room for around 1,500 skaters. Whether patrons were participating in the waltz contest, attending the "Roller Dance," meeting up with friends, or just there to listen to the music, the rink was a gathering place for anyone to enjoy. The rink was closed about 50 years later but the memories remain.

Elaine Zayak, who was born and raised in Paramus, was a world-renowned figure skater in the 1980s. When Zayak was a baby, she lost three toes in a lawn mower accident, and her doctors prescribed figure skating as a physical therapy method. Zayak continued on to become the 1981 US Figure Skating Champion, the 1982 World Figure Skating Champion, and placed sixth at the 1984 Winter Olympics in Sarajevo.

In 1966, Collete Daiute, a Paramus resident, won the Miss Teenage America contest, broadcast live from the close by Palisades Amusement Park. This event had every Paramus resident on the edge of their seats. Daiute was fairly young and graduated from Paramus High School one year later, in 1967.

The Miss Paramus Beauty Pageant was held for several years before its discontinuation. Michelle See, who was Miss Paramus in 1965, is pictured here with Mayor Robert J. Inglima at the Steak Pit restaurant.

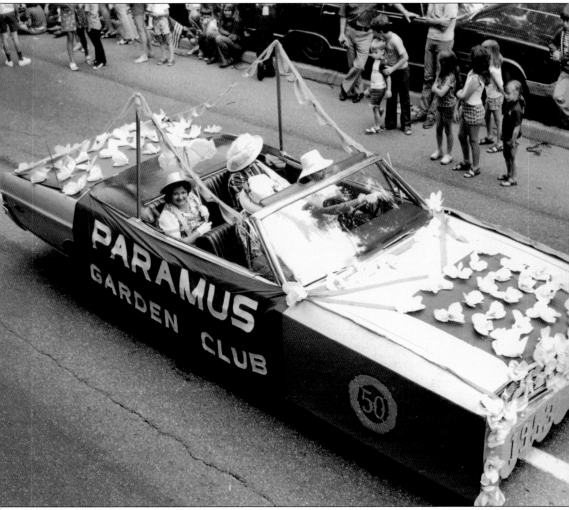

A Paramus Garden Club seems redundant in the farming community that Paramus once was. However, this picture was taken in 1972, after the definitive decline of farms. Since there were fewer farms in the area, the appreciation of growing a garden as a hobby or cultivating enough food for one's family was very high because the lack of fresh fruits and vegetables was a recent development.

Bowling, a common pastime especially amongst the working-class German, Polish, and Italian populations, reached the height of its popularity in the 1960s. Paramus Lanes, the town's own bowling alley, appeared on the 1950s television shows *Make That Spare* and *Championship Bowling*, and bowling legends Lou Campi and Graz Castellano also bowled there. The bowling alley was famous, drawing people from the entire tristate area, as well as celebrities like Joe Louis and Jayne Mansfield.

Paramus High School, home of the Spartans, offers a wide range of varsity, junior varsity, and freshmen sports in the fall, winter, and spring seasons. In addition to high school sports, Paramus is the home to Paramus Recreation, an organization for adult and youth athletics, including track and field, lacrosse, softball, basketball, soccer, tennis, golf, skating/hockey, cheerleading, football, volleyball, and wrestling. The program also offers arts-and-crafts classes and summer camps held at a few schools.

The Woman's Club of Paramus, located on Ridgewood Avenue, was formed as a nonprofit organization in 1944. According to oral history, five women who were asked to raise money for a neighborhood Scout troop founded the club. Women at the time were starting to head to the workforce more and more, leaving behind the myth of the stay-at-home mother. Today, the Woman's Club works to support the welfare of the community, donating time and money to schools, libraries, and a number of organizations.

Michael J. Petruska Jr. Memorial Park is located on Farview Avenue near the intersection of Midland Avenue. There are a few playgrounds, a baseball field, a basketball/roller hockey court, a handball wall, and several picnic tables. Several residents recall that, in the 1960s, a letter was sent to the Bergen County mayors stating that a national committee in Washington, DC, would give the Cleanest Town Award. Paramus residents entered the contest and worked to beautify the town by creating an "instant park." After an all night plant-a-thon, Petruska Park was made on a tract of donated land by a builder named Michael Petruska Jr. Although Paramus did not win the contest, on the official opening of the park in April 1969, Lady Bird Johnson arrived to present the second-best award. In 2013, the borough implemented the Paramus Farmers' Market on Wednesdays in the summer, held in the north parking lot of the park. Vendors offer snacks, meals, and fresh produce, as well as various other items such as soaps and skincare products.

Van Saun County Park, created in 1957, covers 146 acres of land between Continental Avenue, Howland Avenue, and Forest Avenue. The beautiful park includes the Bergen County Zoo, pony rides, a carousel, a miniature train ride, picnic and fishing areas, athletic fields, playgrounds, a large pond, and the historic Washington Spring Garden. This garden is where General Washington passed through often near his encampment in September 1780. Van Saun Park is named after Jacob Van Saun, who bought 224 acres of land in the area from Albert Zabriskie in 1695.

Seven

RECENT HISTORY

Fritz Behnke was the town historian of Paramus until he passed away in 2012. Before the Fritz Behnke Historical Museum was created in 2003, he conducted school tours in his barn. He was singularly dedicated to the preservation and study of Paramus's history.

Fritz Behnke, before the establishment of the Fritz Behnke Historical Museum, conducted school tours and field trips in the barn (on the left) next to his house. Fritz was honored with a Commendation Award from the Bergen County Historic Sites Advisory Board for his work as curator of the Behnke Barn. The collection was mostly farm tools and household items at the time. (Courtesy of the Tax Assessor's Office.)

The Fritz Behnke Historical Museum held their grand opening in September 2003. The move from Fritz Behnke's barn to the museum officially consolidated his collection with donations from other Paramus residents. There are more than 2,000 items currently on display at the museum.

In July 2007, Paramus was lucky to have the Woodstock legend Richie Havens at its band shell. A year later, in August 2008, Paramus also had the pleasure of welcoming the American folk singer Pete Seeger to town. Today, the music continues with the Terrific Tuesdays and Wacky Wednesdays Summer Concert Series, presented by the Paramus Cultural Arts Council.

In June 2012, the Paramus Rotary Club celebrated the installation of a peace pole adjacent to the Paramus Band Shell at the public library. The peace pole had "May Peace Prevail on Earth" inscribed in a different language on each side of the pole. Each language represents the major languages most spoken in Paramus as of 2012 to promote multicultural understanding and global peace. The project, which was funded by donations, also included a gazebo, several benches, plantings, markers, and engraved pavers.

In the summer of 2013, in an effort to increase mental health awareness, the Paramus Stigma Free Task Force in conjunction with the Paramus Mayor & Council declared Paramus the nation's second and Bergen County's first "Stigma-Free Zone." Lawn signs were put up around town, such as this one at borough hall shown above, to spread the antistigma campaign. Mental health stigma is defined as the mark of disgrace or disapproval of those with mental illness.

Now with over 26,000 residents, 8 public schools, over 16 public parks, more than 30 private schools, over 30 houses of worship, and a number of shopping centers, the borough of Paramus continues to grow and adapt with the 21st century.

DISCOVER THOUSANDS OF LOCAL HISTORY BOOKS
AND MILLIONS OF VINTAGE IMAGES

history publisher in the United States,
ible and meaningful through publishing
heritage of America's people and places.

Find more books like this at
www.arcadiapublishing.com

Search for your hometown history, your old
stomping grounds, and even your favorite sports team.

Consistent with our mission to preserve history on a local level,
this book was printed in South Carolina on American-made
paper and manufactured entirely in the United States. Products
carrying the accredited Forest Stewardship Council (FSC) label
are printed on 100 percent FSC-certified paper.

MADE IN THE